Images of Modern America

ALBUQUERQUE INTERNATIONAL BALLOON FIESTA®

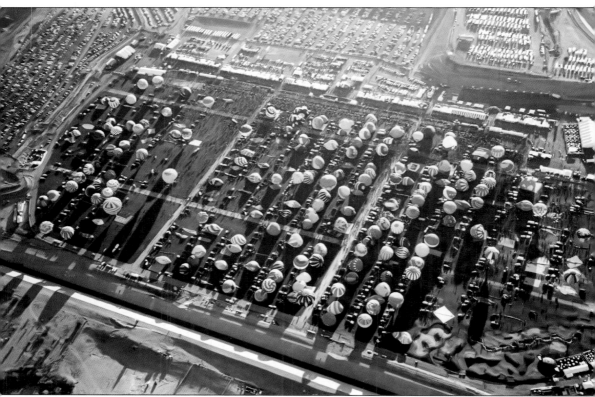

In 2003, there were 728 balloons registered and flying from Balloon Fiesta Park. This park—the sixth and current launch field used by the Albuquerque International Balloon Fiesta (AIBF)—was dedicated in 1996. The sight of balloons laid out, inflating, and taking off is as spectacular from 1,000 feet as it is from ground level. (Tom McConnell.)

ON THE FRONT COVER: More than 500 hot air balloons ascend on any given weekend morning each October. The *Fiesta* balloon is owned and flown by several officials of the AIBF. The view in this image looks southwest over Balloon Fiesta Park in northwest Albuquerque, New Mexico. (Nienke Bos.)

ON THE BACK COVER: Clockwise from top: A crowd's-eye view of a mass ascension (Paul deBerjeois); one of four after-dark balloon glows throughout Balloon Fiesta week (Paul deBerjeois); balloons awaiting takeoff officiated by launch directors affectionately known as "Zebras" (Paul deBerjeois); the sky filled with balloons in a "visual feast" (Bennie Bos)

Images of Modern America

ALBUQUERQUE INTERNATIONAL BALLOON FIESTA®

DICK BROWN
JOHN DAVIS
CHARLOTTE KINNEY
TOM MCCONNELL
DICK RICE
JOHN SENA
KIM VESELY
FOR
ALBUQUERQUE INTERNATIONAL
BALLOON FIESTA HERITAGE COMMITTEE

ARCADIA
PUBLISHING

Published by Arcadia Publishing
Charleston, South Carolina

Printed in the United States of America

Library of Congress Control Number: 2016941021

For all general information, please contact Arcadia Publishing:
Telephone 843-853-2070
Fax 843-853-0044
E-mail sales@arcadiapublishing.com
For customer service and orders:
Toll-Free 1-888-313-2665

Visit us on the Internet at www.arcadiapublishing.com

This book is dedicated to the thousands of volunteers who donate their time, energy, and talents to insure a safe, fun-filled Albuquerque International Balloon Fiesta each year.

CONTENTS

FOREWORD

Through colorful words and steady camera lenses, the Albuquerque International Balloon Fiesta really comes into focus in this book. Authored by seven seasoned balloonists, it brings the world's most photographed air show to life.

As the Balloon Fiesta evolved over time, it developed a number of signature events—the weather-testing Dawn Patrols, the ever-popular weekend mass ascensions, the world-class Flights of the Nations, the mind-boggling Special Shape Rodeos, and the dazzling Balloon Glows. This book highlights each of these events while simultaneously exposing the reader to the joy of Fiesta fun-flying.

On any given day on the launch field, the Balloon Fiesta merges 500 or so balloons with 80,000 spectators. It is here where members of the camera-wielding public have an opportunity to interact with the balloon pilots, observe the inflation and liftoff, and savor a high as grand as the Sandia Mountains east of Balloon Fiesta Park.

My late husband, Sid Cutter, an aviator who simply loved to fly, first envisioned an eye-catching advertising medium and, later, a balloon club that would allow licensed balloon pilots to teach club newcomers to fly balloons. When he was approached about holding a worldwide contest in 1973, he was thoroughly bitten. And then, one thing led to another . . . and the rest is history.

Sid would be very proud to be part of this book.

—Jewel Cutter
Albuquerque, New Mexico
February 14, 2016

ACKNOWLEDGMENTS

The authors wish to acknowledge the photographers whose willingness to share their colorful images has made this book such a fascinating record of our 45-year Albuquerque International Balloon Fiesta (AIBF) saga.

Unless otherwise noted, all photographs appear courtesy of their respective photographers, and all photographers are credited at the ends of the captions accompanying their respective photographs.

Pictured are the seven authors of this book—from left to right, Tom McConnell, Charlotte Kinney, Dick Brown, John Davis, Kim Vesely, John Sena, and Dick Rice. (Ty Young.)

INTRODUCTION

Once upon a time in November, awestruck spectators gawked in amazement as a hot air balloon rose majestically into the sky. Aboard were two intrepid aeronauts: an erstwhile scientist and explorer and a nobleman along for the ride. Their ascension created a sensation. Huge crowds gathered, souvenir sellers hawked balloon-bedecked merchandise, and no doubt there were food vendors doing a brisk business in breakfast burritos and funnel cakes.

The year was 1783, just outside of Paris, but other than the burritos and funnel cakes, this sounds like a description of Albuquerque during its famous International Balloon Fiesta. At that historic balloon ascension in 1783, the awestruck spectators included King Louis XVI and Benjamin Franklin, who was then serving as the US minister to France. Balloons have been a fascination for centuries, and the Albuquerque International Balloon Fiesta (AIBF) is perhaps the epitome of that phenomenon.

The brave pilots during that 1783 flight—Jean-François Pilâtre de Rozier and François Laurent, the Marquis d'Arlandes—flew a hot air balloon invented by two papermaking brothers, Joseph and Étienne Montgolfier. De Rozier and d'Arlandes burned straw and wool over an open fire to keep the balloon aloft and constantly had to wield a wet sponge on a stick to put out sparks before they hit the envelope. Their 23-minute flight across Paris was the first successful ascent by humans into the heavens. It was followed just days later by the first flight of a hydrogen gas balloon, which was piloted by J.A.C. Charles and Nicolas-Louis Robert. The exploits of these early aeronauts were the spaceflights of their day—the scientific equivalent of going to the moon—and were every bit as much of a sensation as the first flights of modern astronauts.

A century later, an Albuquerque bartender, "Professor" Park Van Tassel, flew a gas balloon as part of the city's Fourth of July celebration. Van Tassel's flight was followed by a handful of other gas balloon ascensions in the 1890s and the first decade of the 20th century, but by then, the newfangled airplane had become the more practical flying machine. Balloons were suddenly rather passé and remained so for more than half a century.

In the late 1950s, the US Navy needed a less-expensive alternative to its gas balloon training program. Raven Industries, of Sioux Falls, South Dakota, designed and built a hot air balloon featuring an envelope of calendered nylon and an onboard butane burner in the gondola. On October 22, 1960, Ed Yost flew the Raven Industries prototype to 9,300 feet in about the same time it took de Rozier and d'Arlandes to fly across Paris. The modern hot air balloon was born.

In 1971, aviation entrepreneurs and brothers Sid and Bill Cutter came up with the bright idea of using a hot air balloon as a centerpiece for a huge party held in Cutter Flying Service's hangar at the Albuquerque airport to celebrate their mother's birthday and the company's anniversary.

The Cutters' party—and their Raven Industries balloon—was a hit, and the day after, by accident or by design, Sid flew the balloon for the first time. Rumor has it that he was standing in the gondola of the inflated but rope-tethered balloon reading the instruction manual while Bill wielded a large ax. Bill claims this is not true. But what *is* true is that just as the first Montgolfier flights created a sensation in 18th-century France, Sid Cutter's first balloon flights created a sensation in Albuquerque. Spectators followed the balloon like children chasing after the Pied Piper. In November 1971, Sid and eight friends founded the Albuquerque Aerostat Ascension Association, (AAAA), signed up members to learn to fly, and purchased their first balloon, named *Roadrunner*. This led to more balloon clubs being formed and more balloons flying in the area, and the rest, as they say, is history. The AAAA still exists today and is the world's largest balloon club.

A few months later, local radio station KOB was preparing to celebrate its 50th anniversary and wanted to do something really big and spectacular. The station approached Sid Cutter about bringing his balloon to the event, which soon morphed into the idea of staging the "world's largest" balloon race—which, at the time, consisted of 13 balloons!

Sid Cutter and Tom Rutherford, who then worked as an announcer for the station, invited 21 balloons, and the rally was on. Only 13 balloons actually made it to Albuquerque (bad weather in Chicago held up the shipment of many of the others), but it did not matter to the awestruck crowd of 20,000 people who turned out to see the launch. Officials of the Balloon Federation of America who were in attendance were equally impressed and encouraged Sid Cutter and the City of Albuquerque to host the first World Hot Air Balloon Championship. The 13 balloons that had seemed such a sensation in 1972 swelled to 138 at the 1973 World Championship. As an addition to the championship, an earlier elimination contest whittled down the competitors from about 100 balloons to select the entrants from the United States, and the Albuquerque International Balloon Fiesta was on its way to becoming one of the world's greatest aviation spectacles.

There were bumps in the road, of course, and at one point, as Sid Cutter became financially unable to sustain the event on his own, it looked like the Balloon Fiesta might have to fold. Cutter famously said, "I know there's money in ballooning; I put it there." In the mid-1970s, Albuquerque's then mayor, Harry Kinney, and local citizens rallied to save the event and permanently put it in the hands of a nonprofit organization. This effort, coupled with the prestige of the second World Hot Air Balloon Championship in 1975, secured the Balloon Fiesta's future.

At the same time, gutsy Albuquerque balloonists fired the imagination of the world with daring, world record–setting flights. In 1978, Ben Abruzzo, Maxie Anderson, and Larry Newman became the first to realize the long-held dream of crossing the Atlantic Ocean by balloon in the *Double Eagle II*. They landed in the outskirts of Paris, where de Rozier had made his historic flight in 1783. Anderson, with his son Kris, went on to complete the first nonstop crossing of North America, and Abruzzo and Newman, with Ron Clark and Rocky Aoki, flew the first manned Pacific Ocean crossing in 1981. In the spirit of these amazing ballooning pioneers, in 2015, Albuquerque's Troy Bradley and Russia's Leonid Tiukhtyaev bested most of their records by completing the first gas balloon crossing of the Pacific Ocean since Abruzzo and Newman's flight. The Anderson-Abruzzo Albuquerque International Balloon Museum, opened by the City of Albuquerque in 2005, recognizes the exploits of these and other ballooning pioneers.

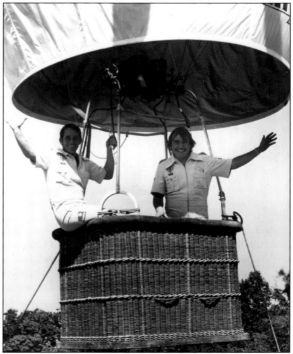

Sid Cutter (left) and then New Mexico state senator Tom Rutherford promote the 1975 Balloon Fiesta. (AIBF.)

Over the years, the Balloon Fiesta has grown and expanded. In addition to the signature morning hot air balloon mass ascensions and balloon competitions, festival organizers added the early-morning Dawn Patrol (which began in 1978 and became an official event in 1991), the spectacular nighttime static balloon displays known as Balloon Glows (which began in 1987), and a series of events devoted to fantastic, whimsical, and ever-inventive specially shaped balloons (which began in 1989). Gas balloons have also been a Balloon Fiesta feature since the early 1980s, and the event now hosts America's Challenge, which was founded in 1995 and is one of the world's two great long-distance races for gas balloons. There is much more information about all of these events in the following pages.

The Albuquerque International Balloon Fiesta, held each year during the first week in October, truly became the party that changed a city. In the Balloon Fiesta's 45-year history, thanks to this unique and spectacular event, millions of people have experienced the same sense of awe that King Louis, Benjamin Franklin, and crowds of Parisians felt at those very first balloon ascensions.

We, the authors, have had the privilege of experiencing the beauty and sensation of balloon flight, the friendships ballooning forges, and—above all—the opportunity to share the sport with others. We hope the photographs and descriptions in this book give readers just a taste of the joy and wonder that is the Albuquerque International Balloon Fiesta.

—Dick Brown, Tom McConnell, Kim Vesely
2016
www.balloonfiesta.com

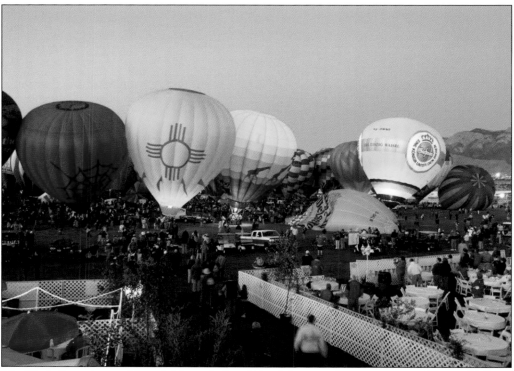

The *Zia* balloon (second from left), symbolic of New Mexico, takes center stage during a Balloon Glow. (Bill McConnell.)

One

AN OVERVIEW OF THE FIESTA

Many phrases have been used to illustrate and explain what exemplifies the Albuquerque International Balloon Fiesta, including "A Carnival in the Sky," a "Visual Feast," "Floating Color and Magic," and "Balloons Galore." This chapter presents an introduction to some of the smaller featured events within the main event. Although the first balloons in Albuquerque were powered by coal gas and hydrogen, the invention of the modern hot air balloon in the early 1960s created the possibility for any person with a few thousand dollars to own a balloon and fly it using a relatively cheap fuel source—propane.

Similar to airplanes, helicopters, blimps, and virtually anything else that flies, balloons are classified by the Federal Aviation Administration as aircraft, and as such, they must be constructed, registered, maintained, and repaired in accordance with strict federal standards. Balloon pilots must be trained and certified by FAA-certified instructors, and all balloon events must be safe and run by experienced balloonists.

The main Balloon Fiesta event in the early 1970s featured the inflation, flying, and deflation of hot air balloons, sometimes in all-together launches, sometimes in simple competitions. The man behind all this was Sid Cutter. In the mid-1970s, the mayor of Albuquerque, Harry Kinney, stepped in to help save the Balloon Fiesta and help form the embryo of the organization that exists today. The Balloon Fiesta's Balloon Glows, Special Shapes, Dawn Patrol, competitions of various sorts, mass ascensions, and more came later.

Here we go!

—Tom McConnell

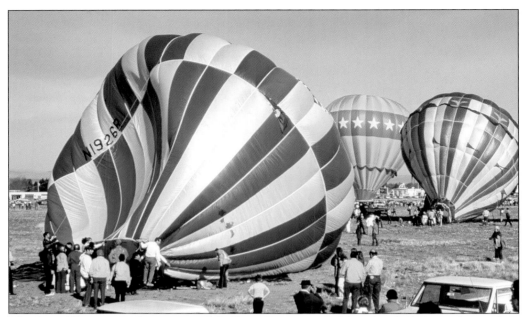

The first Albuquerque International Balloon Fiesta was held in April 1972 at a large, then unoccupied field that was the site of a future expansion of a retail shopping mall. Sid Cutter collected 13 balloons from around the United States for a race. Aviation legend Don Piccard took first place, and his wife, Willie, took second place. (Dick Brown.)

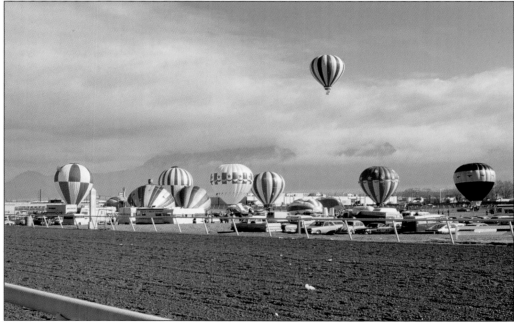

In February 1973, the first World Hot Air Balloon Championship was held at the New Mexico State Fairgrounds. This was also the second Balloon Fiesta hosted by Sid Cutter. The festival included 142 balloons from around the world. Dennis Floden, from Michigan, became the first world hot air balloon champion. (Tom McConnell.)

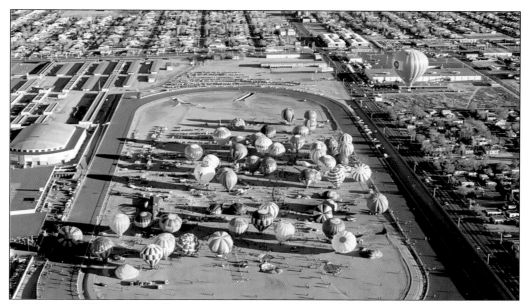

In February 1974, the third Albuquerque International Balloon Fiesta was held at the New Mexico State Fairgrounds. This event included 111 balloons from the United States, and several other countries participated. This was the third Balloon Fiesta hosted by Sid Cutter, and again he lost money. This turn of events forced him to face the choice of either cancelling the next Balloon Fiesta or getting help from some other source. (Tom McConnell.)

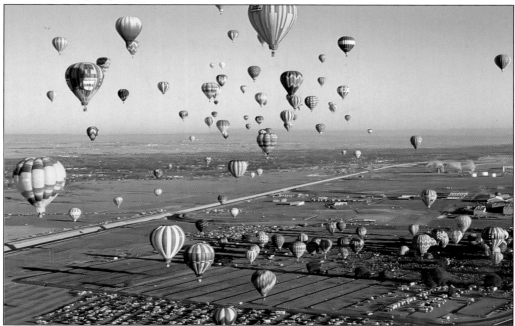

Simms Field, the third launch site for the Balloon Fiesta, hosted 170 balloons in October 1975. This was also the site of the second World Hot Air Balloon Championship held in Albuquerque, hosted by the Albuquerque International Balloon Fiesta, Inc., set up by then mayor Harry Kinney to help preserve this now world-famous event. (Tom McConnell.)

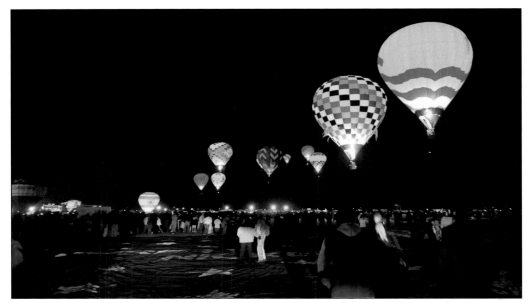

Special events have been added to the main Balloon Fiesta over the years. Two such events occur either before sunrise (Dawn Patrol) or after sunset (Balloon Glow). In the Dawn Patrol event, balloons fly out of the launch field in the early morning, and the Balloon Glow happens in the early evening. This photograph shows the Dawn Patrol event against a black sky. (Paul deBerjeois.)

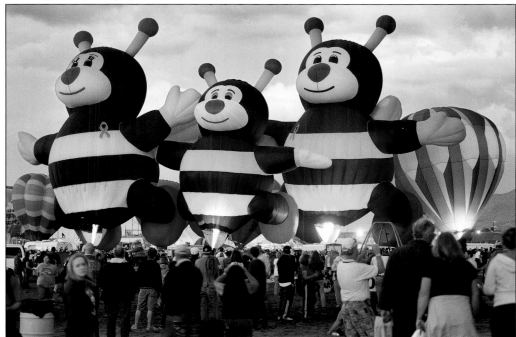

Balloons created in special shapes became popular in the 1980s. Scores of these are featured at Balloon Fiesta every year. The shapes and colors are left to the imagination of the owner and the engineer—and the fullness of his or her pocketbook. These actually fly more or less like normally shaped hot air balloons. (Paul deBerjeois.)

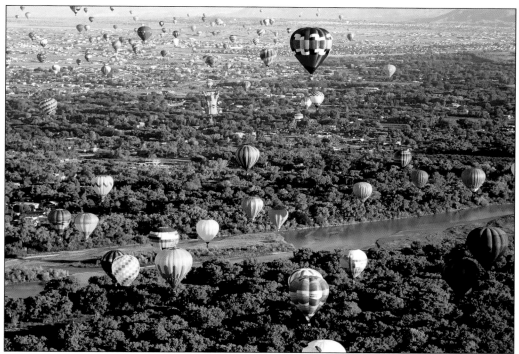

Hundreds of balloons flying over the mighty Rio Grande exemplify the spectacle of color on display for all those who live in the towns and villages of Albuquerque, Corrales, Rio Rancho, Bernalillo, and Los Ranchos, as well as the pueblos of Isleta, Sandia, and Santa Ana. (Tom McConnell.)

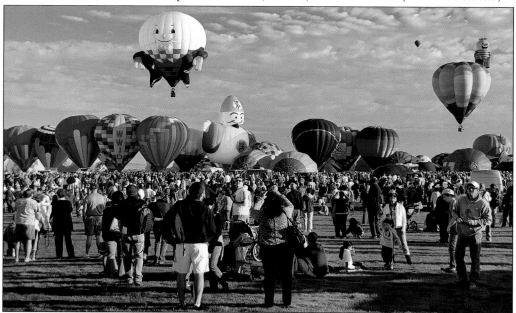

Crowds at the launch site are huge, especially for weekend mass ascensions, Balloon Glows, and Special Shape events. It is not uncommon to have 80,000 or more people on the field at one time. (Paul deBerjeois.)

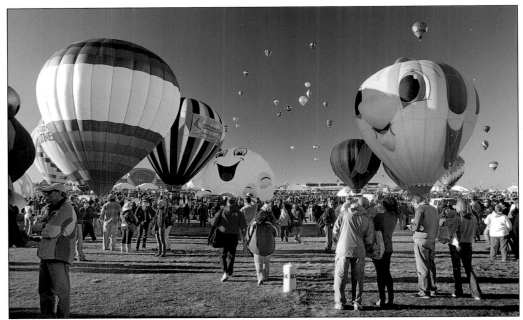

Cell phones and fancier cameras occupy the attention of most guests on the field—and all over the landscape—as balloons launch and then fly away during weekend mass ascensions or fly into the field during weekday competitions. (Paul deBerjeois.)

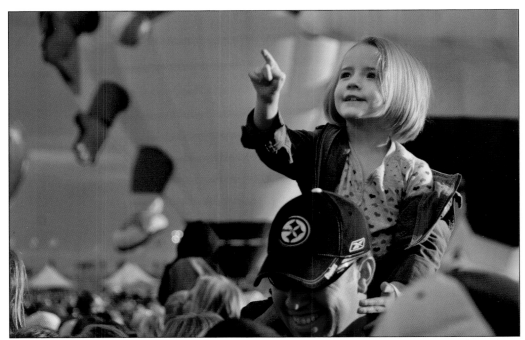

Children especially enjoy the carnival in the air, and they bring their moms and dads to share what they see. (Paul deBerjeois.)

Many of the competitive events involve pilots launching at least a mile away from the launch field, then maneuvering to a target and getting their own baggie very close to a target—in this case, an "X" in the center of the field. Many pilots who fly in Albuquerque are experts in this exercise, accumulating points that go toward a new truck, a motorcycle, cash, or some other prize. (Paul deBerjeois.)

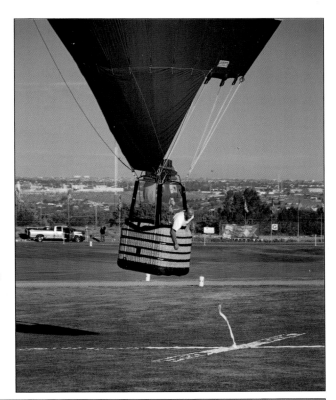

Gas ballooning requires a special balloon inflated with either helium or hydrogen. This harkens back to the earliest days of ballooning in Europe. These pilots usually launch in the evening and stay aloft for several days and nights. From Albuquerque, some gas balloons have flown as far as the East Coast and landed in the United States or Canada within sight of the Atlantic Ocean. (Tom McConnell.)

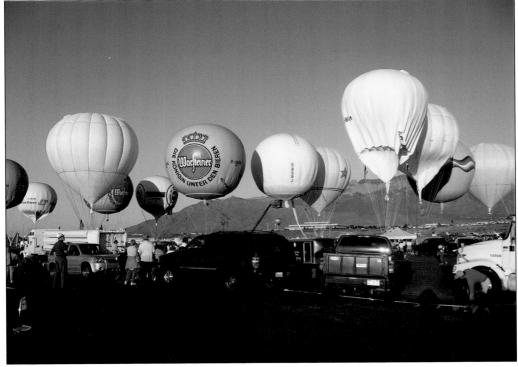

These two men—Sid Cutter (left) and Harry Kinney—are credited with creating and financing the earliest Balloon Fiestas, thus assuring the continuation of the annual event. Both men were passionate about this world-famous event, the corporation—Albuquerque International Balloon Fiesta, Inc.—that supports it, its economic impact on the community, and the beauty of the balloons themselves. (AIBF.)

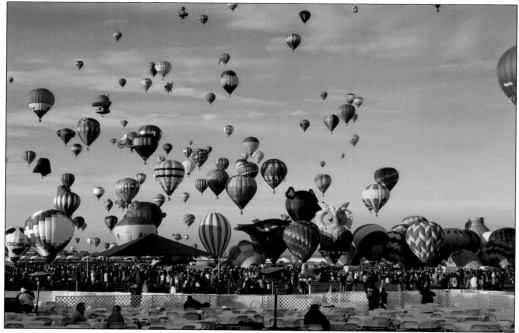

This is what Balloon Fiesta looks like from the Sponsor Hospitality Area, an area on the south end of the launch field set aside for advertising sponsors and sponsored pilots. (Tom McConnell.)

Launch directors conduct and coordinate the balloon launches. They authorize pilots to inflate and launch their balloons in accordance with the balloonmeister and event director, who direct the flying events. They have become known as Zebras due to their referee jackets (and supplemental Zebra costumes). (Paul deBerjeois.)

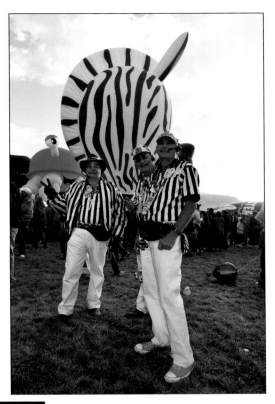

Ed Yost, the inventor of the modern hot air balloon with airborne heater (a propane burner), was an aeronautical engineer involved in balloon research as early as World War II. He was the "clerk of the course" (later called balloonmeister) for the first World Hot Air Balloon Championship in 1973. (Craig Kennedy.)

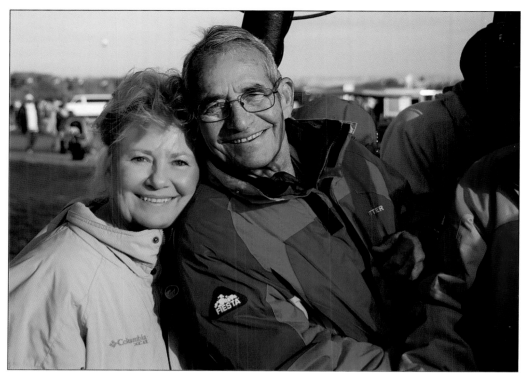

Jewel and Sid Cutter are pictured at the Balloon Fiesta in October 2010. Sid died in 2011, and Jewel carries on his memory in many ways. In 2015, a bronze sculpture of Sid was unveiled in front of the Sid Cutter Pilots' Pavilion on the launch field. (Paul deBerjeois.)

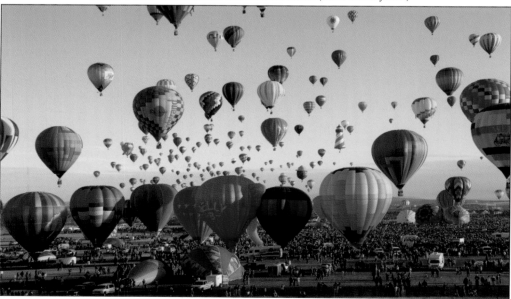

This introduction is intended to entice the reader to dive into the rest of this book to learn more about the history, drama, and beauty of the Albuquerque International Balloon Fiesta held each year during the first full week of October. (David Villegas.)

Two

Mass Ascension, Fiesta Fun-Flying, and Competition

On the first and second Saturday and Sunday mornings of October, as the sun rises over the majestic Sandia Mountains, Balloon Fiesta Park comes alive with the raucous noise of several hundred inflation fans and the roar of propane burners. The senses are assaulted by the noise and the visual effect of 100 or more colorful balloon envelopes entering into a dance with gravity as they fill with cold air from the inflator fans and then stand erect after the cold air is heated by the propane burners.

The field is alive with movement as spectators maneuver their way to their favorite balloon, hoping for a few words with a pilot, a photo opportunity, or a trading card to add to their children's or their own collection. Spectators are mesmerized as they suddenly realize that all they can see in any direction are hot air balloons straining to be set free from the surly bonds of Mother Earth. Suddenly, a whistle pierces the cacophony, and an apparition appears in black-and-white garb—perhaps even wearing face paint—to accept the pilot's launch ticket and move away to begin the launch sequence. Once the sky above is clear and spectators are moved from the downwind path of the balloon, the "Zebra" gives a thumbs-up to the pilot and the balloon takes to the sky with several hundred other balloons heading toward a destination determined by the winds in a very popular event at the Albuquerque International Balloon Fiesta: the mass ascension.

On weekdays, many pilots will launch from the field and fun-fly with crew or friends, while others proceed to a launch site one mile from the center of the field to participate in competition events called a "fly in task" to the field. Competitive events have included Texas Hold'em, a popular card game, played by pilots dropping baggies on oversize playing cards located on the field within a roped-off scoring area, or a plastic ringtoss in which the pilot is required to drop a 12-inch ring on a pole within the scoring area, or to drop a baggie inside a small boat set up on the field within the scoring area. These scoring opportunities occur on different days and can require different piloting skills. Scores are kept and tabulated, and each of the overall top ten winners receives a trophy suitable for displaying back home as a testament to his or her incredible performance during the Albuquerque International Balloon Fiesta.

On those days when the winds take the balloons to the west, many pilots test their skill (or good luck) by descending to the Rio Grande and executing a landing on the surface of the water in a maneuver called a "splash 'n' dash," which allows the balloon to be carried by the current, much like a sailboat. The trick is to remain on the surface without sinking or getting the passengers' feet wet.

The following pages show the mass ascension as well as fun-flying and competitors dropping baggies on scoring targets.

—Dick Rice

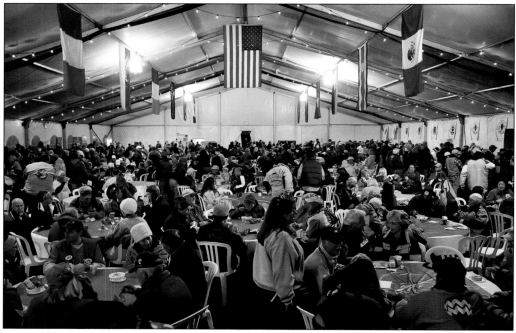

Pilots and crew gather for breakfast before heading out to the pilot briefing. (Paul deBerjeois.)

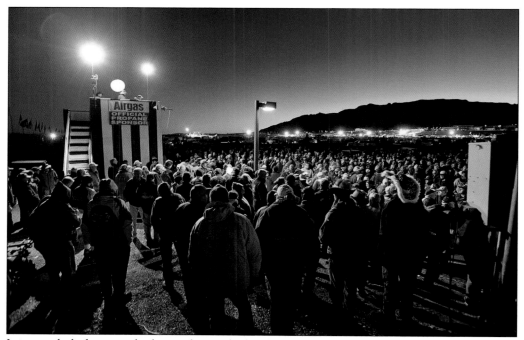

It is zero dark thirty, and pilots gather at the briefing tower for the mandatory daily weather and safety briefing before participating in the day's flying events. (Paul deBerjeois.)

In the process of assembling the balloon, the pilot checks the burner system for leaks and proper functioning. (Paul deBerjeois.)

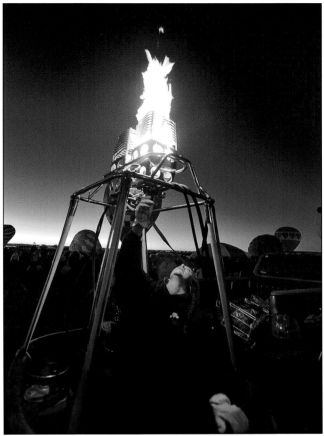

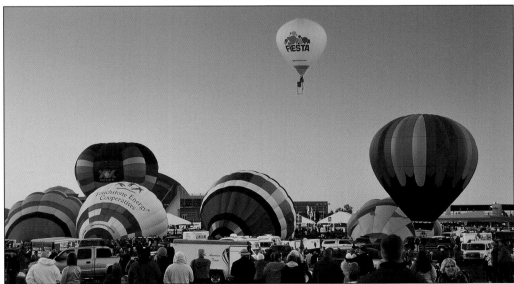

On the first day of the Balloon Fiesta, the Fiesta balloon carries the United States flag aloft while the national anthem is played or sung. (Paul deBerjeois.)

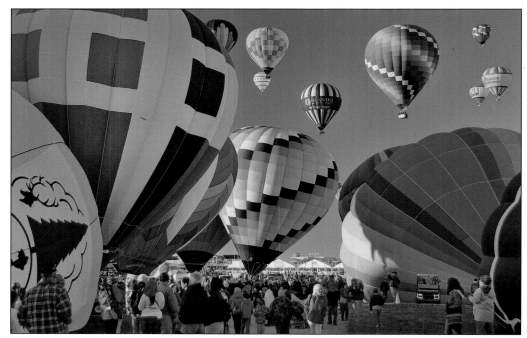

Huge crowds are mesmerized by the awesome launch of multicolored, many-shaped balloons ascending effortlessly into a beautiful New Mexico fall morning sky. (Paul deBerjeois.)

The look of wonder reflected in a child's eyes as she watches the spectacle unfold is mentioned over and over when pilots describe why they enjoy participating in the world's premier ballooning event. (Ray Watt.)

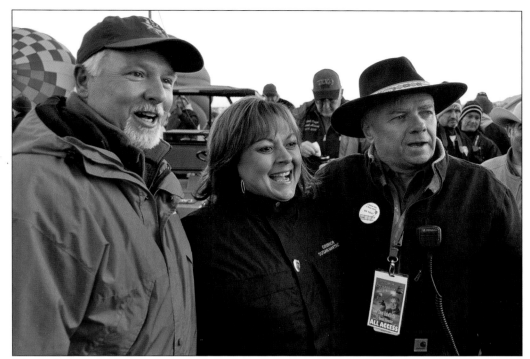

The smile on New Mexico governor Susana Martinez's face while watching balloons ascend with Sam Parks (left), 2014 balloonmeister, and Don Edwards, 2014 event director, is as telling as the look on the face of the young girl on the previous page. No matter one's age, the Albuquerque International Balloon Fiesta is a fun- and awe-filled event for both young and old. (Paul deBerjeois.)

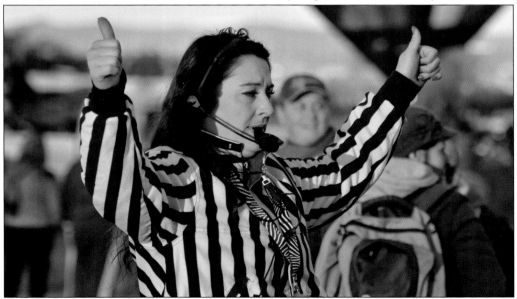

Launch directors play a crucial role in launching balloons safely in a mass ascension. Pilots may not leave the field until being given the "thumbs up" signal by a launch director—more commonly referred to as a "Zebra" due to the black-and-white official jackets. (Ray Watt.)

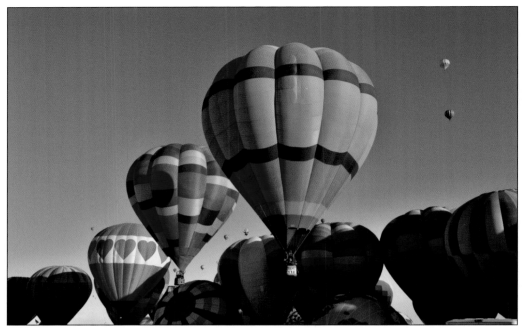

Zebras work each row on the field, moving downwind to upwind, giving the thumbs-up signal to balloons as each row prepares for launch. (Paul deBerjeois.)

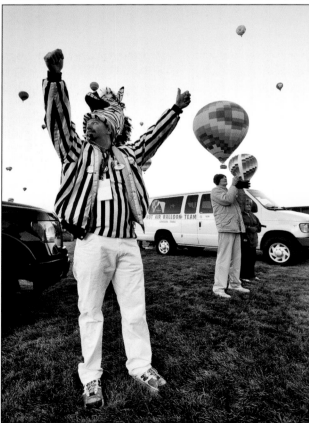

Zebras are very distinctive, so they stand out in the crowd and are easily spotted by pilots. Some really get into the costume, as evidenced by the Zebra hat being worn by this launch director. (Paul deBerjeois.)

Some Zebras bring a little theatricality to the job. (Paul deBerjeois.)

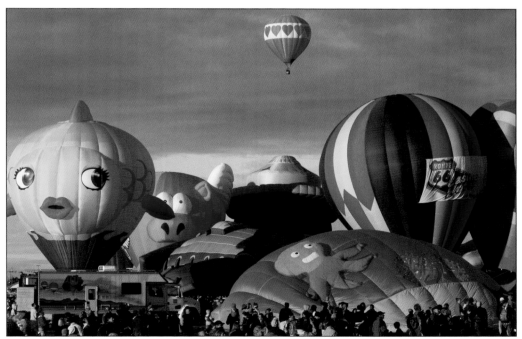

Love is in the air at the Albuquerque International Balloon Fiesta. Some couples have chosen to be married at the Balloon Fiesta in an airborne balloon or on the ground with balloons in the background—a truly memorable experience. (Marlon Long.)

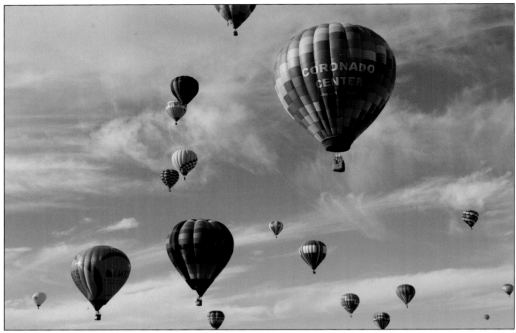

The balloons head off to wherever the winds take them, making memories for those flying as well as those watching. (Marlon Long.)

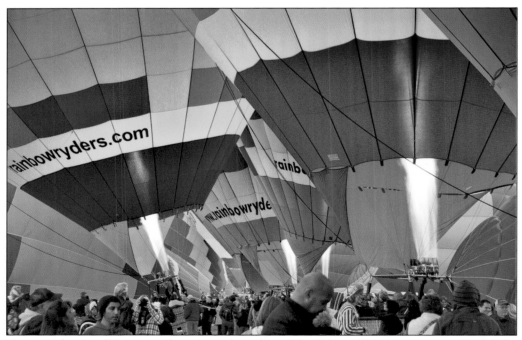

Here, a Zebra is talking to a pilot prior to launching. The Zebra will instruct crew to "walk" the balloon to a less congested area, and after checking the sky for traffic, will give the thumbs-up signal for the pilot to launch. (Paul deBerjeois.)

Balloons fill a cloudless sky during a mass ascension in Albuquerque, New Mexico, on a perfect fall day. (Paul deBerjeois.)

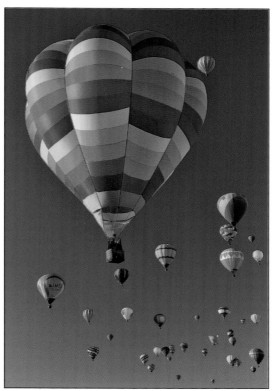

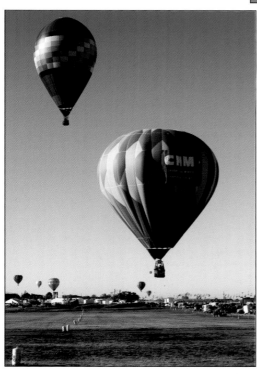

This field has been cleared for competition. (Cindy Hunt.)

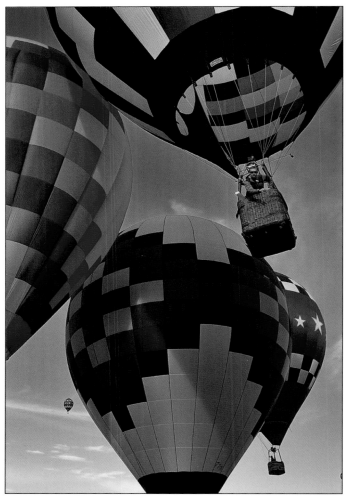

During the target games, it can get very congested around a target, making baggie-dropping difficult. (Paul deBerjeois.)

Official scorers wait for competitors to begin dropping baggies in the boat behind them. (Paul deBerjeois.)

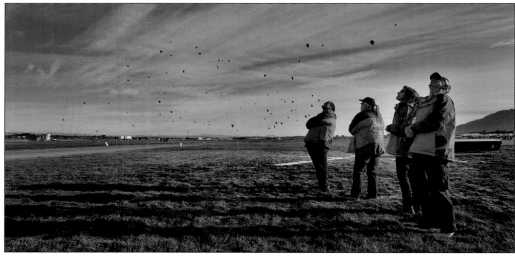

This competitor is dropping a baggie on the "X." The baggie closest to the center of the X wins. If the pilot allows the balloon to touch the ground, the penalty is an immediate loss of competition points. (Paul deBerjeois.)

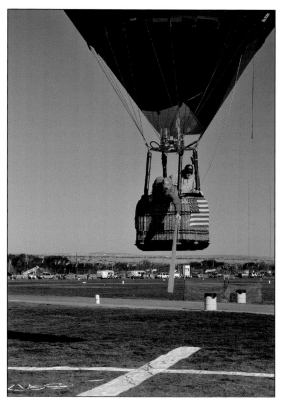

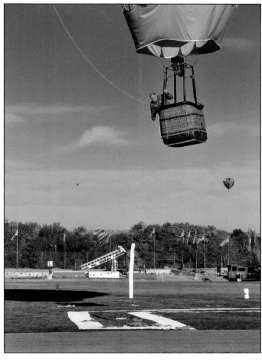

This pilot is making a near-perfect baggie drop from a slightly higher altitude than in the previous picture. Caution rules, as the pilot wants to make sure the balloon's basket does not touch the ground. (Paul deBerjeois.)

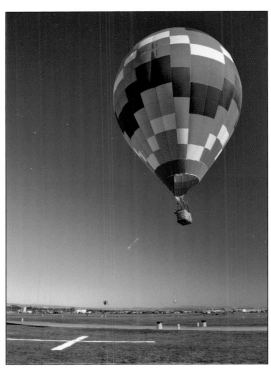

Of course, sometimes a pilot is close but not close enough, so he relies on arm strength to get the baggie to the target. (Paul deBerjeois.)

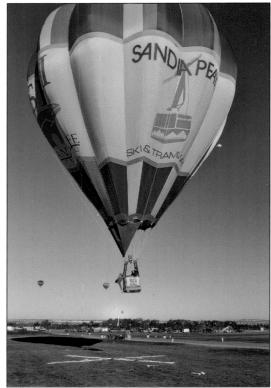

There are also those who concentrate on flying the balloon and let the passenger toss the baggie. (Paul deBerjeois.)

Jewel Cutter, widow of Balloon Fiesta founder Sid Cutter, poses by the boat bearing his name as she waits for competitors to begin dropping baggies in the boat in a variation of the traditional baggie toss on a target. (Paul deBerjeois.)

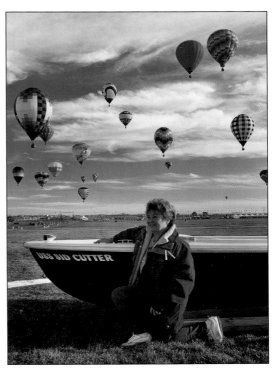

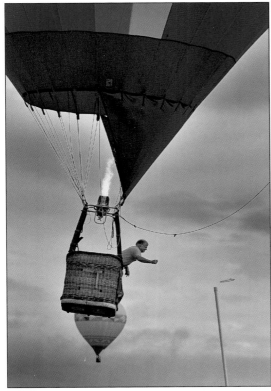

The ringtoss requires more hand-eye coordination than the target drop and is more difficult than it looks. (Paul deBerjeois.)

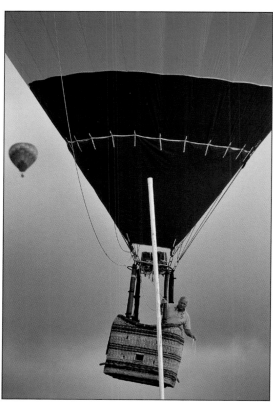

Obviously, it helps to be above the pole when attempting to drop the ring on it. (Paul deBerjeois.)

This is a pilot's view of the field after taking off during a mass ascension. (Paul deBerjeois.)

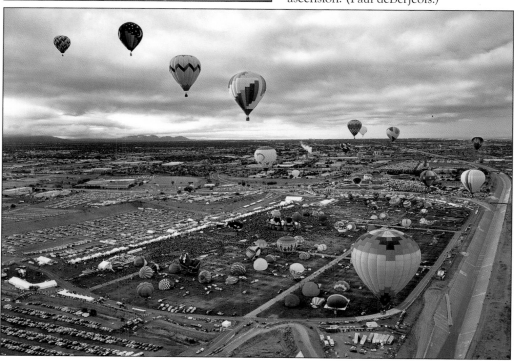

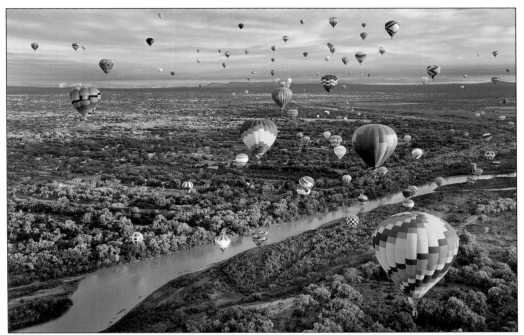

These balloons are crossing the Rio Grande after a mass ascension. Many balloons will attempt a splash 'n' dash—a maneuver which allows the basket to touch the surface of the water without sinking in an experience not unlike sailing. (Paul deBerjeois.)

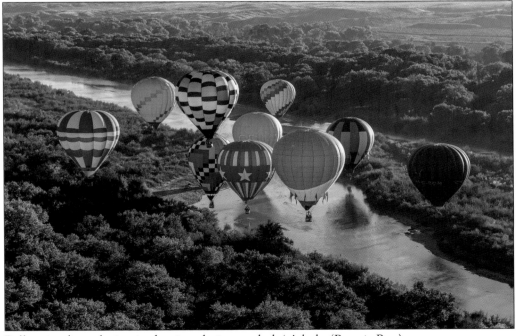

Balloonists love playing in the river during a splash 'n' dash. (Bennie Bos.)

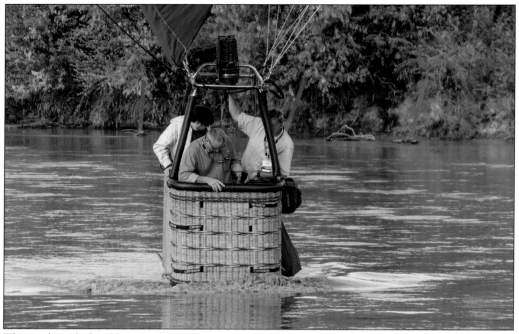

This is the splash! "Hey, my feet are getting wet!" (Bennie Bos.)

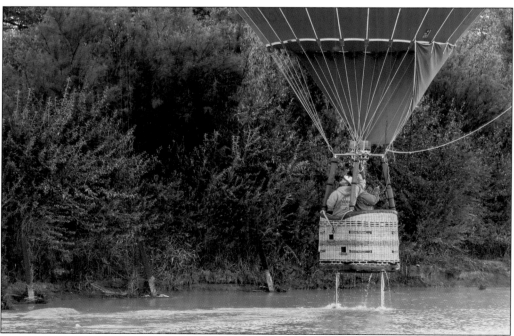

And this is the dash! Note the water draining from the bottom of the basket: "Oh dear, my feet are really cold!" (Nienke Bos.)

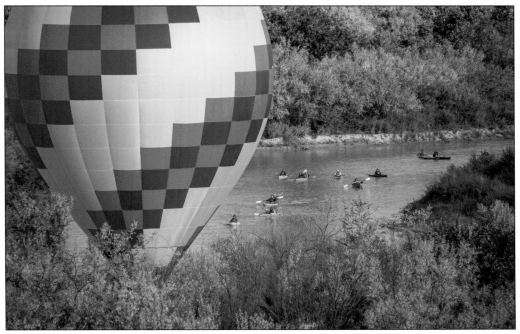

Local kayakers come out to see the balloons on the river. (Bennie Bos.)

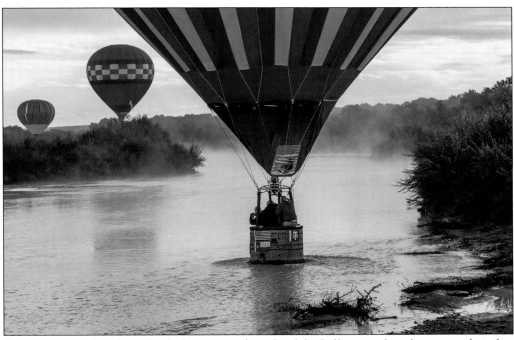

Some pilots, having done this before, sit on the side of the balloon so they do not get their feet wet during a splash 'n' dash. (Nienke Bos.)

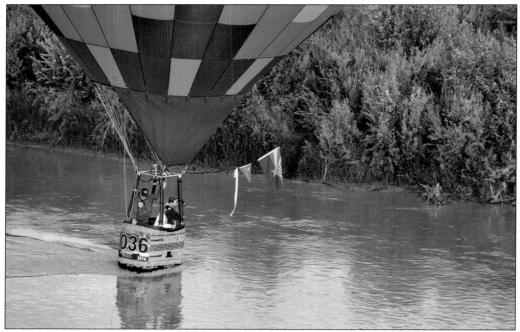

Here is a perfectly executed (so far) splash 'n' dash. Note the wake being generated behind the basket as the wind pushes the balloon on the water, as well as the bottom of the basket sitting on top of the water. (Nienke Bos.)

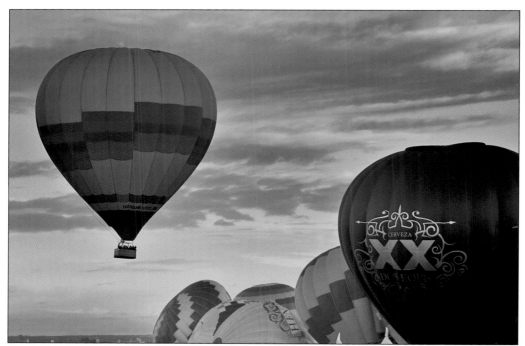

Some people check off a bucket list item by taking a ride in a hot air balloon during a mass ascension at the Albuquerque International Balloon Fiesta. (Paul deBerjeois.)

Three

SPECIAL AND SPECTACULAR EVENTS

Although the Albuquerque International Balloon Fiesta is in itself spectacular, over the years, the organizers have continued to add new events to keep spectators and participants entertained.

In 1981, the first gas balloon race took place, and it continues today in the form of the America's Challenge. The year 1987 brought the wonders of Balloon Glow. From almost the first Balloon Fiesta, pilots flew balloons that were created in shapes other than the normal balloon shape, but in 1989, the Special Shape Rodeo became an official part of the Balloon Fiesta. The early morning event known as Dawn Patrol became official in 1991. In 1997, organizers decided to honor those pilots who were attending the Balloon Fiesta from far-flung places around the world by having a special Flight of the Nations.

These events have become an important part of every Balloon Fiesta and should be a part of any visit to the city in early October; by tradition, the Albuquerque International Balloon Fiesta spans the first two weekends—and the weekdays in between—of October.

—John Davis and John Sena

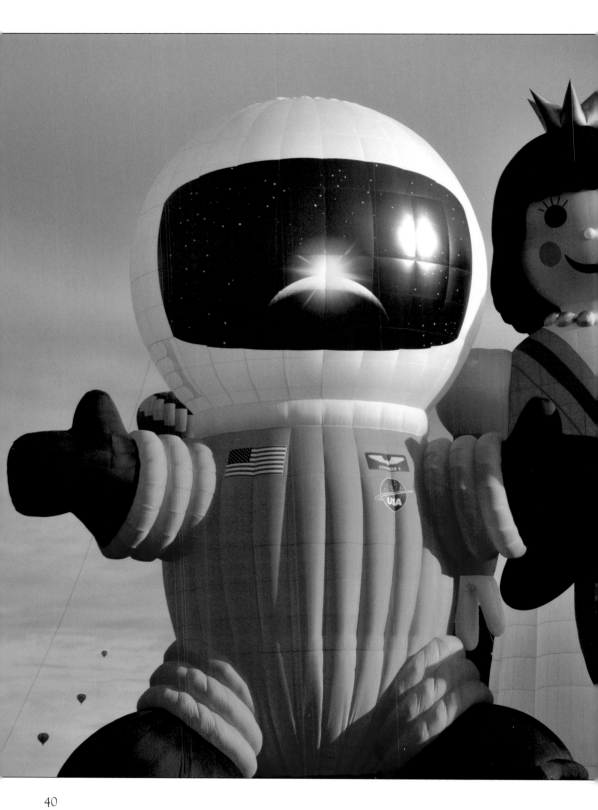

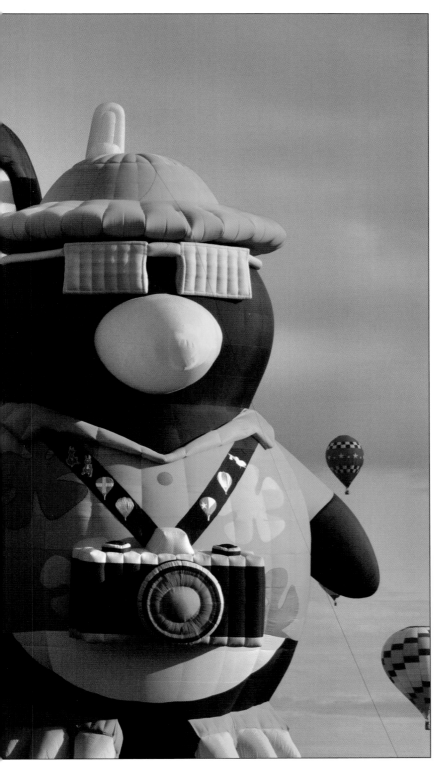

Every day at the Balloon Fiesta features various balloons in special shapes, but on Thursday and Friday, the Special Shape Rodeo takes place. The Special Shape Rodeo draws the largest crowds during the week. Spectators can expect the sky to be filled with more than 100 wonderful shapes from around the world. Many shapes use the Balloon Fiesta as their introduction to the balloon-loving public. They are larger than most naturally shaped balloons and will capture the eye. As visitors walk among these giants, they may also notice that the crews that help get the shapes into the air and safely back on the ground are a great deal larger than the crews for the regularly shaped balloons. The size, weight, and complexity of the construction of these special shape balloons are all factors in the size of the crew—even their chase vehicles are noticeably larger. (Ray Watt.)

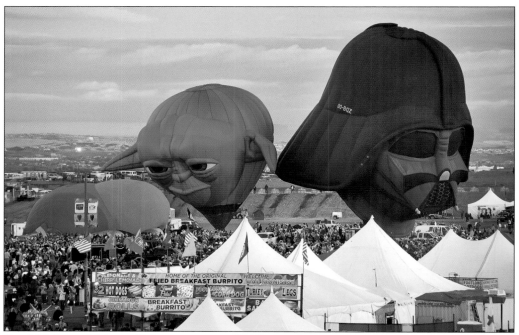

Darth Vader and *Master Yoda* are two popular shapes that come to the Balloon Fiesta. Both of these balloons are from Belgium. The *Darth Vader* balloon comes complete with a Storm Trooper escort. (Paul deBerjeois.)

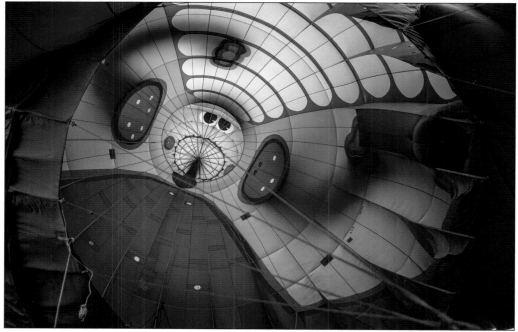

Looking up into a special shape balloon offers an idea of the design and construction. To maintain the shapes of these balloons, complex sets of baffles and rigging are required, as shown in this image. (Bennie Bos.)

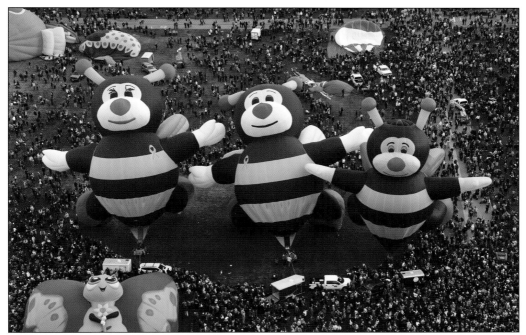

The Bees are always a crowd favorite! *Joey*, *Joelly*, and *Lilly Little Bee* are most often seen together. Sometimes their hands are attached with Velcro at takeoff, challenging the balloons' pilots to stay together. (Ray Watt.)

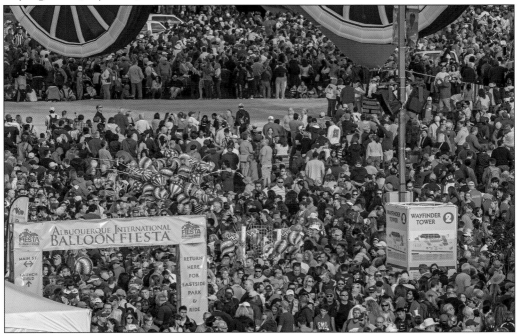

It is impossible to imagine the popularity of the Special Shape Rodeo until one is on the field with thousands of other spectators. The open space in the photograph shows the outline of the Wells Fargo stagecoach that had just been inflated. (Angie Pearce.)

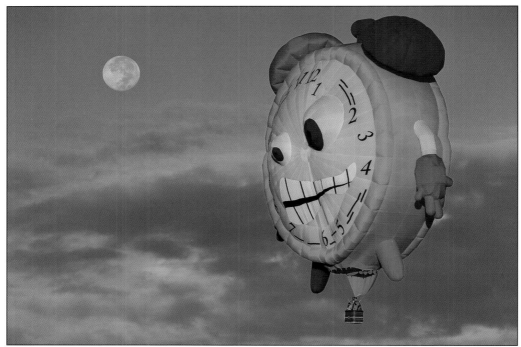

A great imagination and a good engineering staff are all one needs to come up with a special shape design like that of this strange-faced clock, *Tic Toc*, which comes from Brazil. (Paul deBerjeois.)

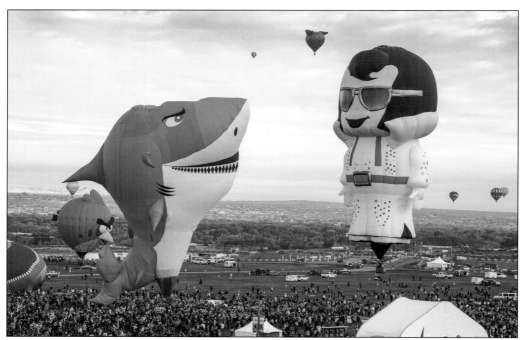

Even the sharks pay attention when Elvis is in the house. *Sharky* and the *Elvis Tribute* are both balloons from the United States. (Bennie Bos.)

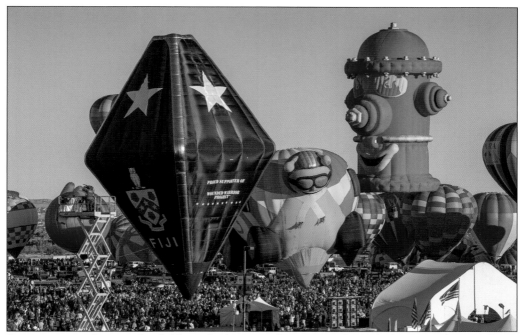

Spectators standing on the field can look in any direction and watch the great shapes take to the sky. (Bennie Bos.)

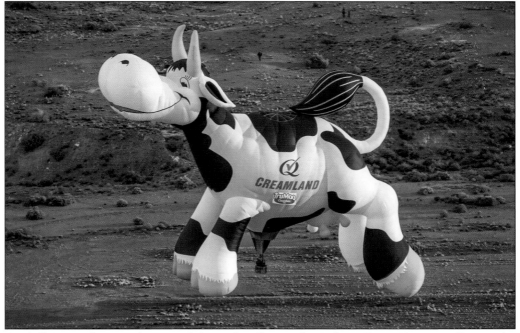

Airabelle is another popular special shape that flies in the Balloon Fiesta. During inflation, the crowd around her is amazing. (Bennie Bos.)

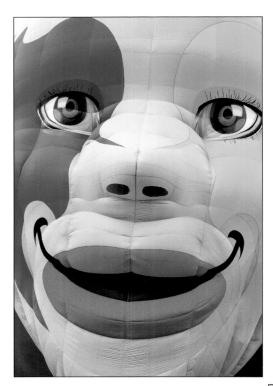

Of the many clowns in attendance, this one—*Triple Clown*, from Brazil—has a particularly real look. The eyes are a real work of art. *Triple Clown* has three different faces. (Paul deBerjeois.)

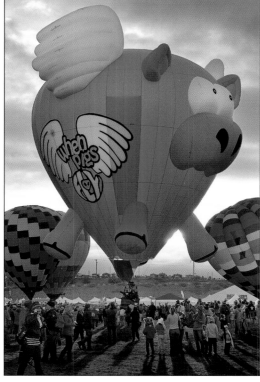

The Balloon Fiesta—and especially the Special Shape Rodeo—proves that pigs can fly. *HamLet*, a special shape balloon from the United States, is one of several pig balloons at the Balloon Fiesta. (Paul deBerjeois.)

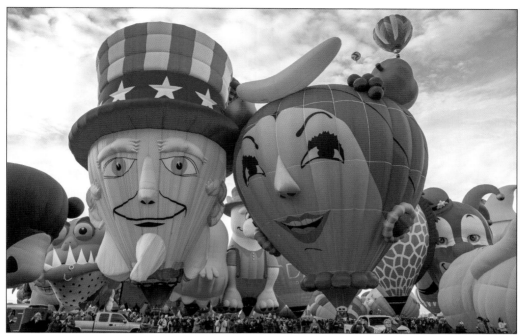

Uncle Sam and *Chic-I-Boom* have been getting together in Albuquerque for more than 30 years. (Nienke Bos.)

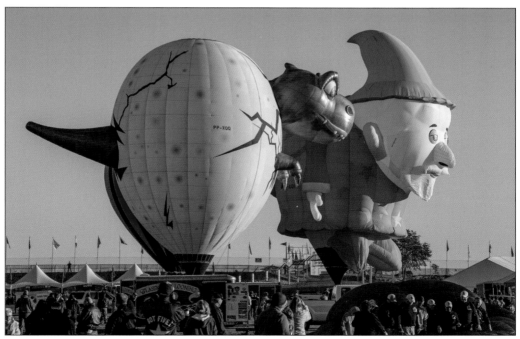

Special shape balloons fall into two categories: appendage, which entails using the basic teardrop shape and adding to it to achieve a design (like the dinosaur emerging from the egg); and full shape, in which the entire envelope is devoted to the image. (Bennie Bos.)

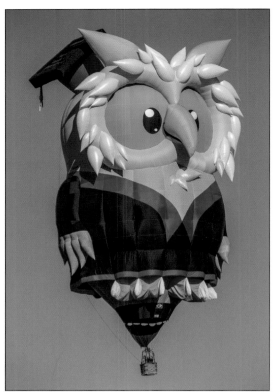

This wise and learned fellow, *Little Wisard*, comes all the way from Brazil. (Bennie Bos.)

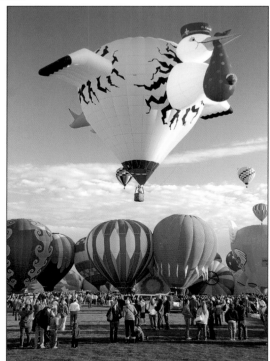

The Stork has been a part of the Balloon Fiesta for many years. It is no coincidence that this balloon is owned and piloted by a local obstetrician. (Paul deBerjeois.)

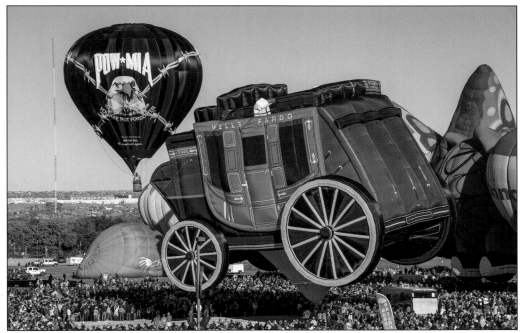

Two iconic balloons, the *POW-MIA* balloon and *Cent'R Stage* (the Wells Fargo stagecoach), always draw huge crowds. Just to the right of the stagecoach is the *Butterfly*, a recent entry to the Balloon Fiesta. (Bennie Bos.)

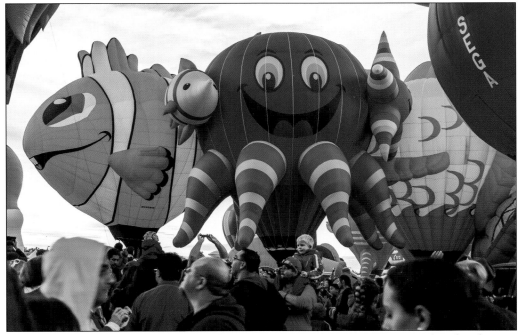

Clownfish *Wally* gets ready for a sky adventure next to a cute octopus covered with other sea creatures. (Nienke Bos.)

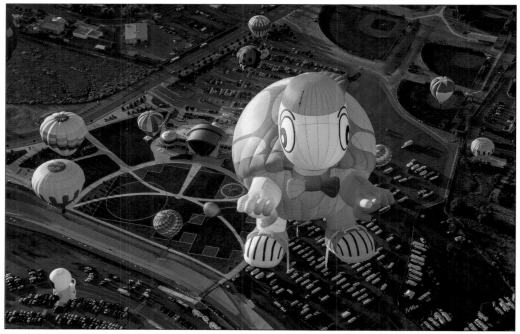

Turtle *Mister Bup*, from Belgium, is flying high over the Anderson-Abruzzo Albuquerque International Balloon Museum just south of the launch site. The museum is a great place for visitors to stop for more information about ballooning while in Albuquerque. (Bennie Bos.)

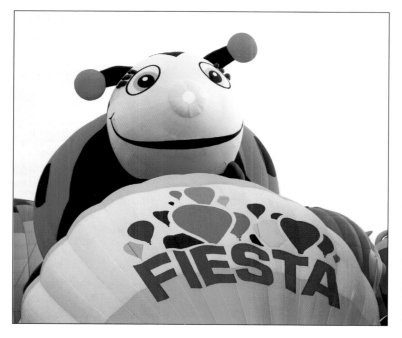

The *Lady Bug* appears to be peeking over the Albuquerque International Balloon Fiesta official balloon. Special shape events have been crowd favorites for many years. (Kim Vesely.)

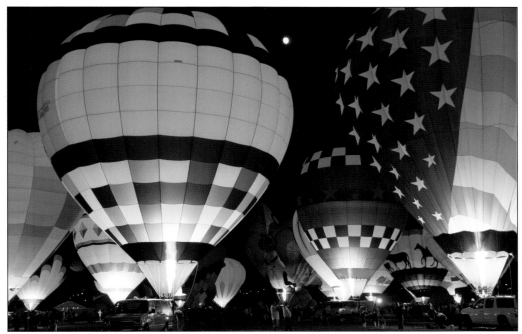

The show the balloons put on during the day is magnified by how they look at night. Imagine 200 or 300 balloons doing an All Burn, which is when every balloon lights its burner at the same time. (Marlon Long.)

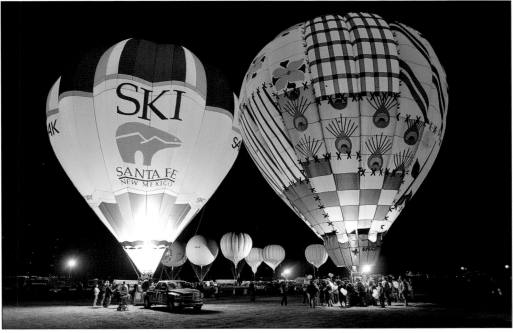

Glowing balloons sometimes give Balloon Fiesta organizers and participants an opportunity to remember some of the late, great Balloon Fiesta pilots. In 2010, Carol Rymer Davis (right) and Richard Abruzzo (left) were remembered by their balloons. (Paul deBerjeois.)

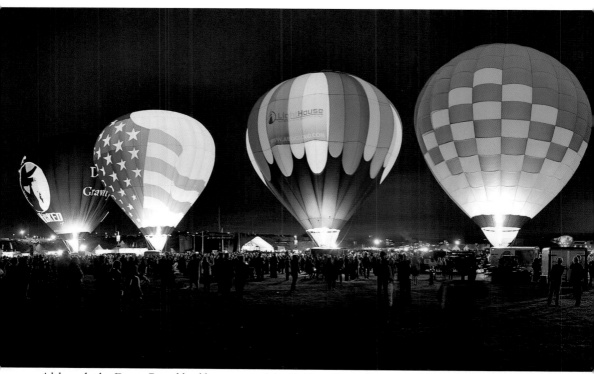

Although the Dawn Patrol had been part of the Balloon Fiesta for many years, it became an official event in 1991. After inflating their balloons before sunrise, these pilots take off and fly until the

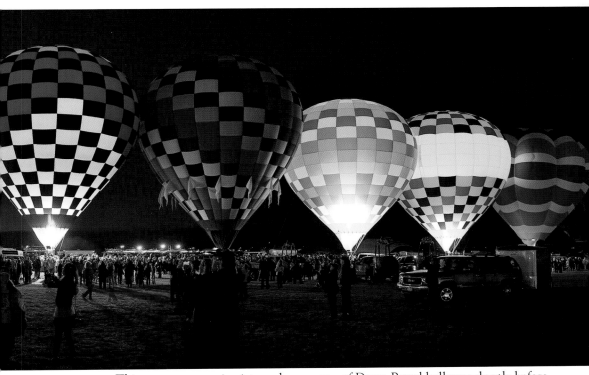

sun comes up. This great panoramic picture shows a row of Dawn Patrol balloons shortly before takeoff. They will put on a short light show on the ground before takeoff. (Paul deBerjeois.)

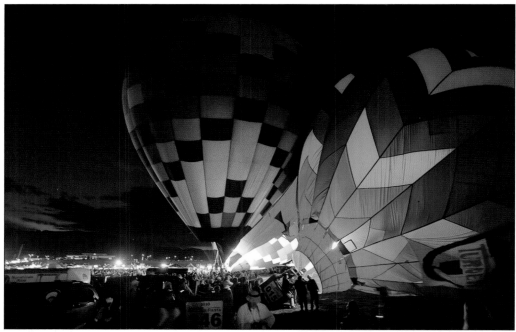

These balloons are inflating as the first rays of the sun begin to light the eastern sky. The shadow of the Sandia Mountains is just becoming visible. (Paul deBerjeois.)

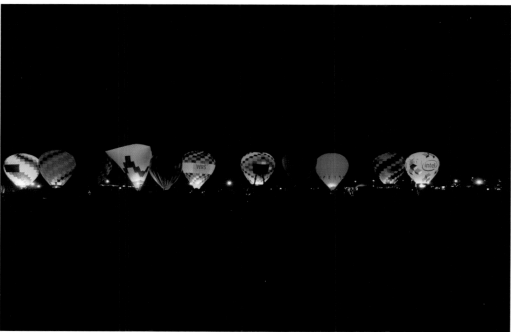

Another group of Dawn Patrol pilots get ready for takeoff. Once the balloons are in the air, spectators can see their navigation lights all the time and their burners when they are needed. (David Villegas.)

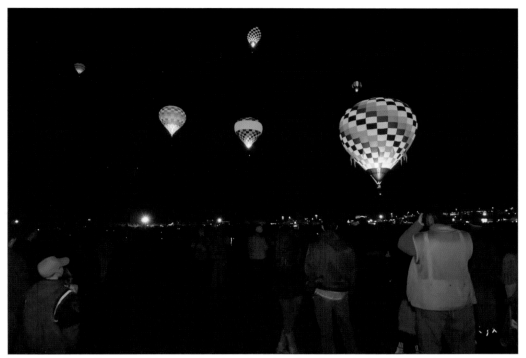

The view from the ground is great, but imagine the view from the balloon as the city, with all its lights, is on display. (Ray Watt.)

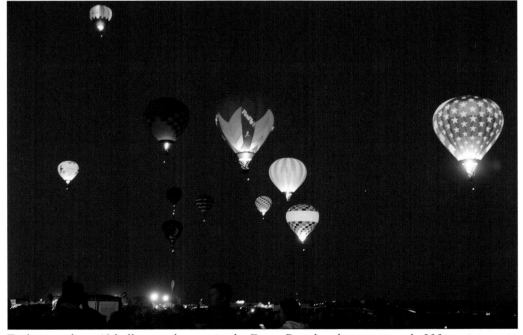

Each year, about 12 balloons take part in the Dawn Patrol and approximately 200 participate in the Balloon Glow. (Marlon Long.)

Albuquerque has been the site of the World Gas Balloon Championship on two occasions and now hosts the America's Challenge Gas Balloon Race each year. Pilots come from around the world to take part in this event. The pomp and ceremony accompanying each liftoff includes

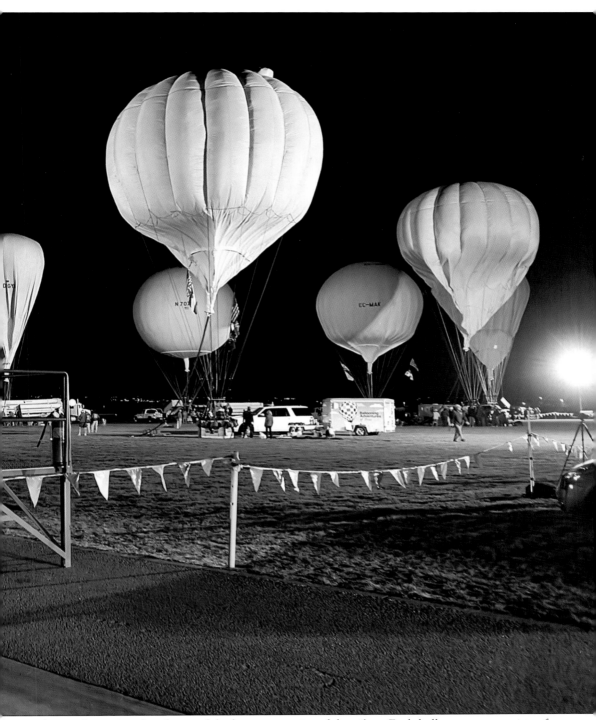

playing the national anthems of the home countries of the pilots. Each balloon team consists of a pilot and copilot, due to the time and distance of the race. Gas balloons have flown as far as the eastern edge of the United States and one landed near the Arctic Circle. (Paul deBerjeois.)

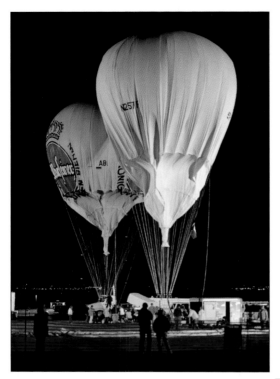

Gas balloons are inflated in the afternoon and generally launched after sundown, since weather conditions for safe launch are better after dark. The lifting gas is either helium or hydrogen. Launch preparation calls for knowledgeable and physically able crews. After the balloons' journeys are underway, chase crews depart to follow and to be in place when the pilots land. Each balloon is equipped with a strobe light beacon and electronic tracking gear. (Paul deBerjeois.)

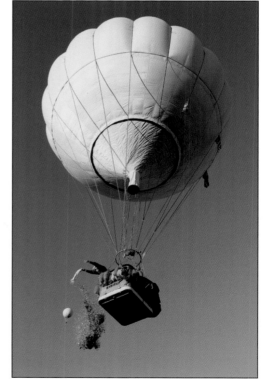

The gas balloons have gondolas with sandbags strapped to them for ballast. When the balloons are completely filled, they reach a state of "equilibrium" that requires them to be held fast by ground crews. In flight, the balloons climb by dumping ballast and descend by opening the valve at the top of the envelope. In past years, the America's Challenge Gas Balloon Race has included former New Mexico governor Gary Johnson in the role of copilot. (Kim Vesely.)

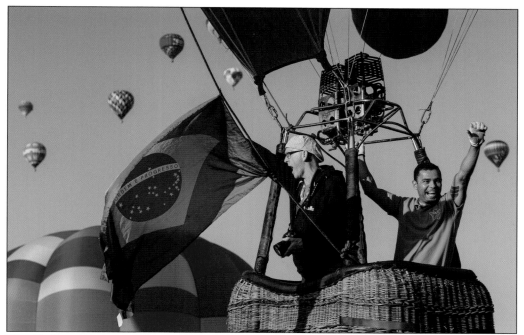

The Flight of the Nations event draws pilots and crews from all over the world. This pilot has come from Brazil to be a part of the festivities. (Nienke Bos.)

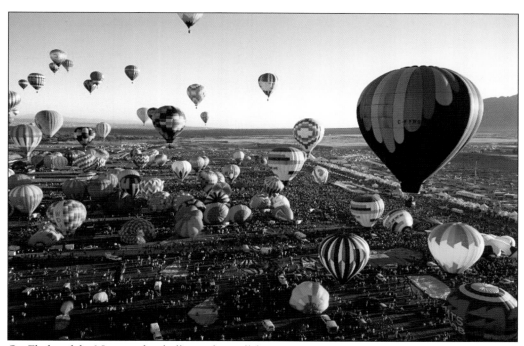

On Flight of the Nations day, balloons from all foreign nations represented (some say this includes the Republic of Texas) take to the air in a mass ascension. (Cindy Petrehn.)

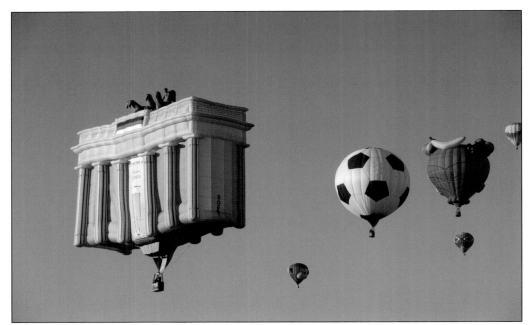

The *Berlin Brandenburg Gate* is a part of a group of special shape balloons originally developed by the late Malcolm Forbes, publisher of *Forbes* magazine. (Bennie Bos.)

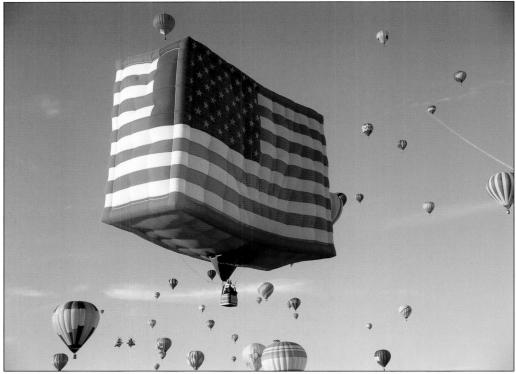

Old Glory has flown in events across the world. It is part of a team that includes a NASA space shuttle balloon that is actually larger than a real shuttle. (Tom McConnell.)

Four

EARLY DAYS

A balloon ascension invariably leaves a strong, lasting and vivid impression on the mind and memory. It attracts all classes, old and young, all tastes and interests, for a balloon ascension is at all times a novel and sublime sight, exhibiting, as it does, man's dominion over the very air he breathes. As a spectacle, it fixes the attention of every beholder.

—*Albuquerque Morning Journal*
June 17, 1882

This could also be said of the modern-day Albuquerque International Balloon Fiesta. Pioneer aeronaut and saloonkeeper Park Van Tassel made Albuquerque history by lifting off solo from New Town in a coal gas balloon on July 4, 1882. When the announced launch time passed, the impatient crowd drifted back to Old Town's Fourth of July celebrations. Finally, Van Tassel was ready, and patrons boarded streetcars for the ride back to New Town, much like many spectators are bused to Balloon Fiesta Park today. Van Tassel's balloon, dubbed *City of Albuquerque*, soared to 14,000 feet, then descended rapidly into a valley cornfield. When he endeavored to surpass his July performance with a September flight at the second annual New Mexico Territorial Fair, Van Tassel's balloon left without him.

Similar fiascos occurred in Albuquerque during the period between 1889 and 1899. For example, Professor Baldwin's balloon unceremoniously dumped him on his posterior; Professor Elmo inflated his smoke balloon only to have it collapse at 200 feet; and Professor Zeno became entangled in ropes during an "illuminated" nighttime ascension—perhaps a precursor to the Balloon Fiesta's famous Dawn Patrol or Balloon Glow.

Putting the dubious track records of barnstorming professors behind them, fair commissioners decided to hire a more experienced balloonist for the 1907 New Mexico Territorial Fair. Joseph Blondin's flight in a hydrogen balloon up the Rio Grande Valley went very well, despite his balloon being shot at eight times over Alameda. Local businessman Roy Stamm flew with Blondin at the 1909 New Mexico Territorial Fair—first in a tethered ascension, then in an attempt at a new long-distance record as they traveled from Albuquerque to New Mexico's eastern plains.

A few gas and hot air balloon experiments were undertaken for science in the 1950s and 1960s, but modern sport ballooning really took hold in the 1970s. During the 50th anniversary celebration of KOB Radio in April 1972, thirteen hot air balloons launched at Coronado Shopping Center—an event then noted as the largest ballooning event in the nation and now recognized as Albuquerque's first "Balloon Fiesta." This was the beginning of an annual series, including the World Hot Air Balloon Championships in 1973 and 1975. The Balloon Fiesta, which started at Coronado and then moved to the state fairgrounds, underwent a steady northward march to its permanent home, Balloon Fiesta Park, which is not far from the Alameda potshots of 1907.

At this grand ballooning extravaganza, one can be mesmerized by balloon glows, teased by mind-boggling special shapes, and drenched in dazzling colors—Van Tassel, Blondin, and Stamm would be absolutely amazed.

—Dick Brown

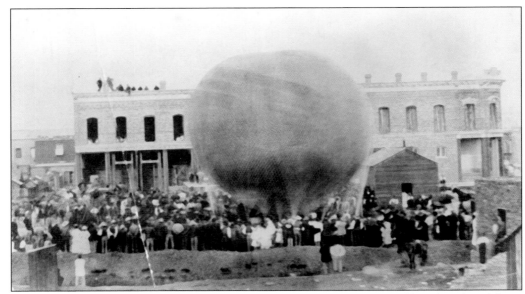

In 1882, launch preparations took place on Second Street between Gold and Railroad (now Central) Avenues for Park Van Tassel's launch of a 30,000-cubic-foot coal gas balloon as part of the city's Fourth of July celebration. During this historic balloon ascension, "Professor" Van Tassel accidentally discovered the now-famous "Albuquerque Box." Amidst winds blowing in opposite directions at two different altitudes, the balloon hesitated about which way to go, then finally drifted northward. (Courtesy of the William Stamm family.)

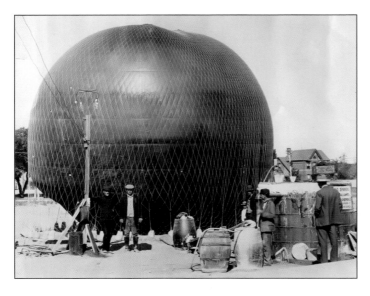

With hydrogen gas generated on-site for balloon inflation, Joseph Blondin and Roy Stamm teamed up for a tethered ascension at the 1909 New Mexico Territorial Fair. Just as the aeronauts began offering rides to paying passengers, Pres. William Howard Taft arrived by special train. After witnessing the balloon swaying on its 500-foot tether, the president congratulated the team on its daring aerial exhibition. (Courtesy of the William Stamm family.)

Joseph Blondin and Roy Stamm's gas balloon prepared to lift off on a historic 90-mile flight from downtown Albuquerque across the Manzano Mountains to Estancia Valley. Near the rural community of Escabosa, the balloon served as target practice for an angry rancher. This flight took place in October—a time of year that now features the annual Albuquerque International Balloon Fiesta. (Courtesy of the William Stamm family.)

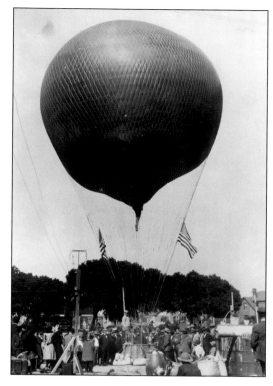

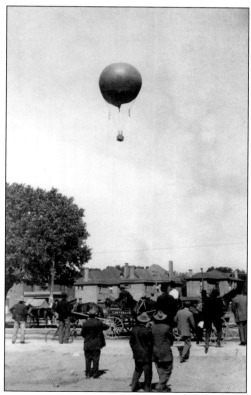

After launching from a vacant lot at Sixth Street and Railroad Avenue, the balloon narrowly missed some trolley wires, then quickly shot up to 5,000 feet, where it veered eastward across the mountains, landing safely on the eastern plains. The launch was witnessed by Albuquerque mayor Lester Felix and a large cheering crowd. (Courtesy of the William Stamm family.)

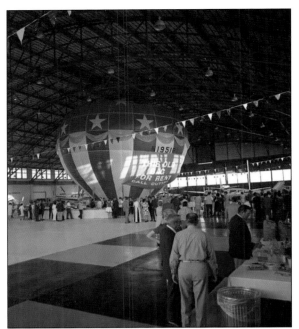

Like Roy Stamm, another local businessman—Sid Cutter—got hooked on ballooning. In June 1971, an inflated hot air balloon jammed against the hangar ceiling of Cutter Flying Service as it served as the centerpiece for the company's 40th anniversary. But it was the "morning-after" free flight by Sid and his brother Bill that gave ballooning its real start in Albuquerque. Sid was a leader with exceptional energy and vision. (Dick Kent.)

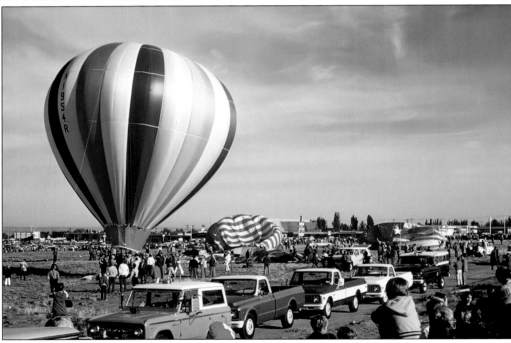

Before organizing the Albuquerque International Balloon Fiesta, Sid Cutter, the first modern-day balloonist in Albuquerque, gathered a group of friends and founded the Albuquerque Aerostat Ascension Association (AAAA), affectionately known as "Quad-A," in November 1971. A few months later, AAAA bought a club balloon and named it *Roadrunner*. In the short span of just two years, AAAA membership soared to 150, making it the largest balloon club in the world. (Dick Brown.)

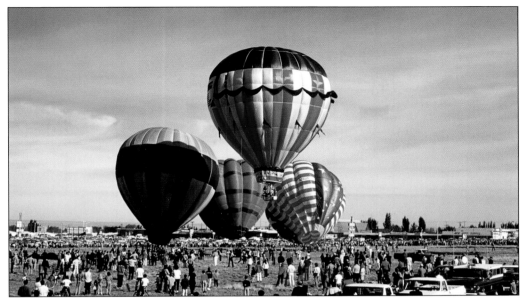

The celebration of the 50th anniversary of KOB Radio presented an opportunity for a balloon rally, and Sid Cutter had been approached by the radio station about staging a race. Albuquerque made history with the largest-ever balloon race in the United States when a crowd of 20,000 watched 13 balloons launch from the Coronado Shopping Center. The April 8, 1972, event eventually came to be known as the first Albuquerque International Balloon Fiesta. (Dick Brown.)

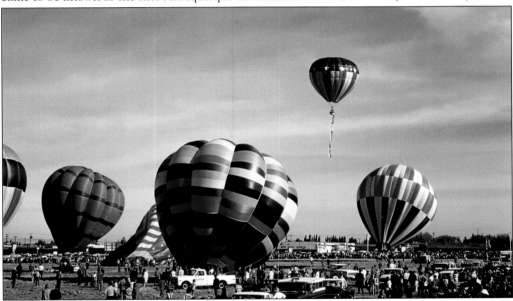

In 1972, a popular spectator competition was the Hare and Hound Race, which involved a lead balloon—the hare—lifting off with the hounds following shortly thereafter. The hound that landed closest to the hare was declared the winner. This race was named and promoted with a southwestern twist as the first annual Roadrunner-Coyote Balloon Fiesta. Its success led directly to the city being selected to host the first World Hot Air Balloon Championship in 1973. (Dick Brown.)

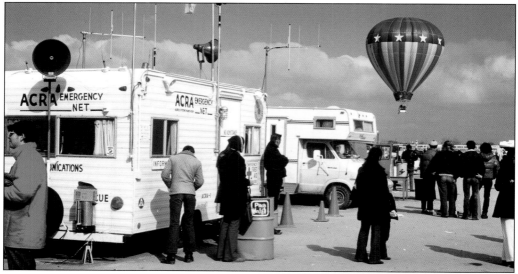

The second annual Balloon Fiesta and first World Hot Air Balloon Championship were staged concurrently inside the racetrack at the New Mexico State Fairgrounds February 10–17, 1973. At the time, Albuquerque had only six resident balloons. The double event was organized and produced by World Balloon Championships, Inc., under the leadership of Sid Cutter and his partner, New Mexico state senator Tom Rutherford. (Dick Brown.)

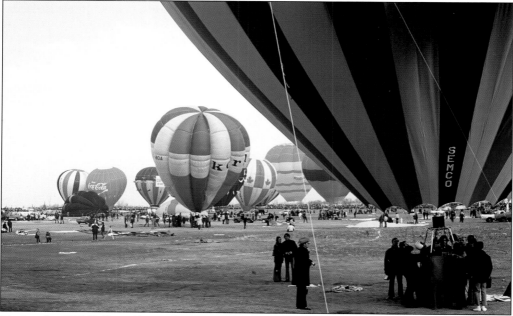

During the 1973 Balloon Fiesta, there were daily flying events with 140 participating balloons—a world record for the number of balloons gathered anywhere to enjoy wind-drifting for the sheer pleasure of it all and to seriously compete for the first world championship. The event was sanctioned by the Fédération Aéronautique Internationale (FAI), and each FAI member nation was allowed four pilots and four balloons. Thirty-two pilots were authorized to compete, including four representing Team USA. (Dick Brown.)

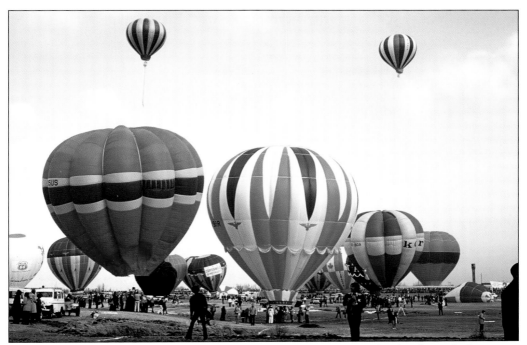

At the 1973 World Hot Air Balloon Championship, pilots flew under the flags of 15 nations: Australia, Belgium, Canada, Denmark, England, Finland, France, Ireland, Italy, the Netherlands, Norway, Sweden, Switzerland, West Germany, and the United States. The international competition included three altitude control events and one spot landing contest. There was no doubt that as a spectator sport, ballooning was looking up. Denny Floden, of Flint, Michigan, became the first world hot air balloon champion, and Bill Cutter placed second. (Dick Brown.)

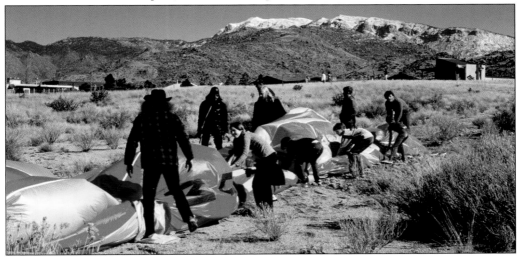

The grand finale of the 1973 championship included a mass ascension of 126 balloons—about half of the world's hot air balloon population—all going up in the air at the same time; this was a new record for sport ballooning. With 942 official balloon launchings over the course of the event, this, too, must have been a record. After the world championship, ballooning soared in the area. By the end of the year, Albuquerque had two dozen local balloons. (Dick Brown.)

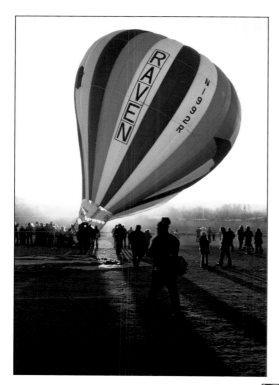

The third annual Balloon Fiesta featured balloons from 29 states as well as five nations, truly making it an international event—a claim that can be made for every succeeding Balloon Fiesta. The 1974 event featured five fun events, including the Tumbleweed Drop. Since there is nothing aerodynamic about tumbleweeds, the drop proved to require more luck than skill. In what has become Balloon Fiesta tradition, the closing event featured a mass ascension. (Dick Brown.)

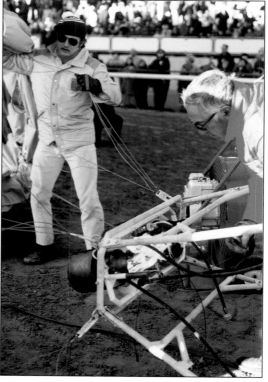

With excitement still high, World Balloon Championships, Inc., organized and produced the 1974 event, again held at the New Mexico State Fairgrounds, with over 110 fun-flying balloons. Many sports have spectators set back from the playing field, and this Balloon Fiesta was no exception; pilots and crews were inside the racetrack, and spectators remained on the outside. This trial separation would change at future Balloon Fiesta venues. (Dick Brown.)

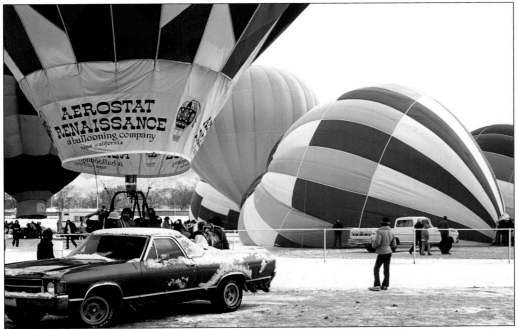

To stimulate interest in a second world championship concurrent with the fourth annual Balloon Fiesta, the Albuquerque Aerostat Ascension Association (AAAA) hosted the Albuquerque Cloudbouncer Balloon Rally on February 22–23, 1975, at the New Mexico State Fairgrounds. Between snow squalls, 40 balloons from eight states and Great Britain lifted off from the racetrack. (Dick Brown.)

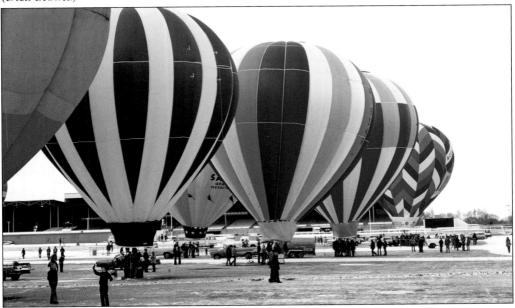

Despite a series of intermittent snowfalls, the Cloudbouncer Balloon Rally was a great success, but it convinced organizers that October would be better than February for the annual Balloon Fiesta. (Dick Brown.)

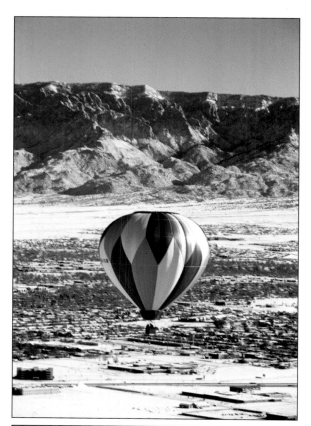

The second day of the 1975 Cloudbouncer Balloon Rally dawned clear and cold. The city and the adjacent Sandia Mountains were blanketed with six inches of snow—a veritable winter wonderland. This did not deter balloonists or spectators. (Bill Flynt.)

The 1975 Balloon Fiesta moved north to Simms Field—an old alfalfa field. This change allowed considerably more maneuvering room, more interaction between balloonists and roaming spectators, and more separation from military and airport facilities. The change in venue also "changed" the weather outlook. Unlike February, with its risk of lingering winter weather, October is often marked by high-pressure systems parked over the Southwest, resulting in clear blue skies and gentle breezes. (Dick Brown.)

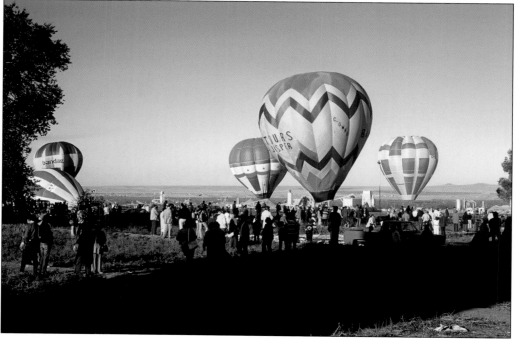

The 1975 World Hot Air Balloon Championship, held from October 2 to October 12, featured 34 competing pilots from 15 nations: Australia, Austria, Canada, Denmark, England, Finland, France, Germany, Ireland, Japan, the Netherlands, New Zealand, Norway, Sweden, and the United States. There were five daily international competitions, followed by fiesta flying. The most challenging task was the barograph flight profile test, but the real crowd-pleasers were the Roadrunner-Coyote race and the convergent navigational trajectile event (CNTE). (Dick Brown.)

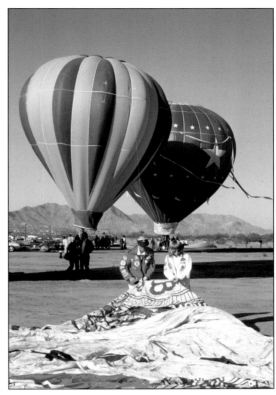

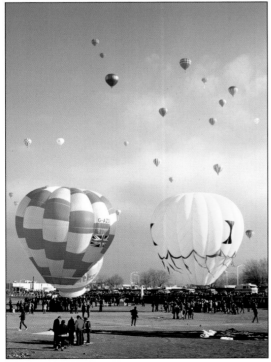

After some serious international competition, Dave Schaffer of Dexter, Michigan, emerged as the new world champion in 1975. On the lighter side, the friendly competition in five waves, Balloon Fiesta fun-flyers tried their hands at the same international contests with the addition of Black Jack and tumbleweed drops. Each pilot, crew member, volunteer, and spectator was convinced that the one who had the most fun was the winner. They were all winners! (Dick Brown.)

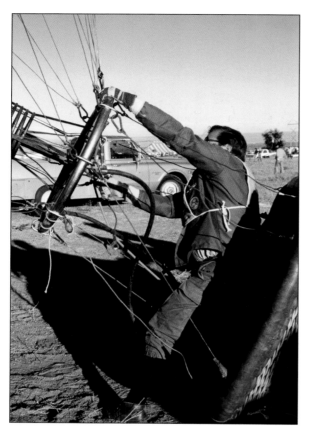

It is a very special experience to be drifting with the wind—destination unknown. For those who encounter the famed Albuquerque Box, it is even more special. The box occurs when there are winds blowing in opposite directions at two different altitudes, making it possible for a balloon to make several passes over the launch field and, on rare occasions, to actually land at the original point of liftoff—a remarkable feat for an aircraft that cannot be steered. (Dick Brown.)

It takes just one long blast of the burners to set a balloon free— detached from all earthly things and floating over the mountains, rivers, and valleys of this planet. Pilots not only drift with the wind, they become part of the wind as it carries them to an unknown destination. (Dick Brown.)

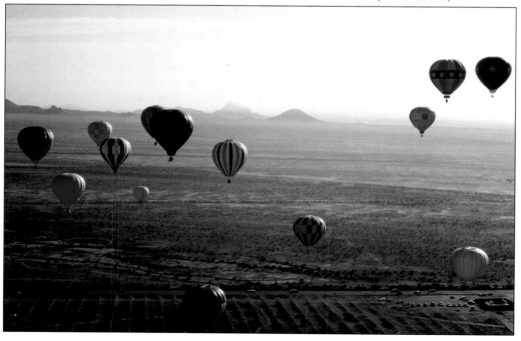

Five

FACES OF BALLOON FIESTA

People are the foundation of the Albuquerque International Balloon Fiesta: the people who love to fly hot air balloons and share the sport with others, the people who love to watch the colorful, ever-changing spectacle, and the people who work year-round to make the event possible. What began as a party planned by Sid Cutter has become an annual event that draws an estimated 950,000 spectators over the course of nine days. That number does not even take into consideration the thousands of locals and their visitors who watch the balloons from their backyards, their office windows, or while driving along the freeway. They may even experience a balloon landing on their street or flying over their backyard—with passengers and pilot waving good morning and every dog in the neighborhood barking an alarm.

Balloonists, by nature, have a spirit of adventure. Is there another sport in which one can take off with no real idea of where their journey will finish? Because a balloon flight is literally "with the wind," it is almost impossible to know exactly where the wind will take the balloon and its crew.

Ballooning is not something one can do alone, because it requires a lot of support, making this colorful, seemingly solitary sport into a group activity. It can be a challenge to land safely in a location where the chase crew can reach the balloon, pack it up, and return to the launch site. Pilots reward their chase crews by giving them rides when possible and providing refreshments after the flight. A good chase crew learns to anticipate the pilot and often arrives at the landing site before or very soon after the balloon. The crew members help stabilize the gondola, get the air out of the balloon envelope, stuff the balloon into the storage bag, then lift the envelope and gondola onto the chase vehicle. It can be hard work, but each trip is an adventure!

—Charlotte Kinney

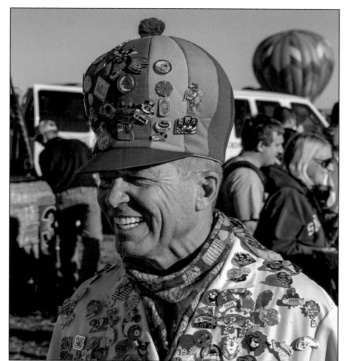

Local weatherman Steve Stucker has been a fixture at the Balloon Fiesta for over 30 years. Every morning, he provides weather forecasts to television viewers, talks to spectators, and promotes the event with his cheery good humor and big smile. His hat, including his balloon pin collection, is auctioned after each Balloon Fiesta, with all proceeds going to charity. (Bennie Bos.)

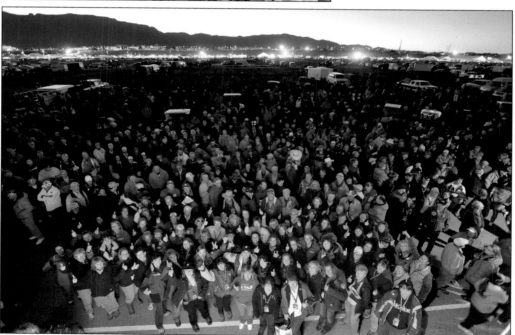

A pilot's typical day during the Balloon Fiesta starts with a pilot briefing long before the sun comes up. Information presented includes the weather forecast (including wind speed and direction), flying events, reminders about safety issues, and anything else that might affect the flight. (Paul deBerjeois.)

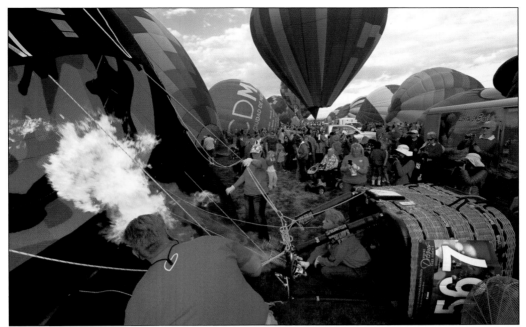

The field contains more than 200 assigned launch sites, with as many as four balloons sharing one site in succeeding "waves." It takes a lot of space to spread out the envelope, fill it with cool air using a fan, then heat the air using the balloon's burner. Each inflation draws a crowd of spectators eager to watch the wonder and enjoy the warmth of the hot air on a cool morning. (Paul deBerjeois.)

The pilot may assign one or more crew members to stabilize the top of the balloon with the "crown line" as the envelope inflates. (Ray Watt.)

Sometimes, when a spectator gets up early and has already watched hundreds of balloons inflate, he just needs a soft resting spot. (Ray Watt.)

Although the balloons are the stars of the show, the looks on the faces of the spectators capture the true magic of the event! (Ray Watt.)

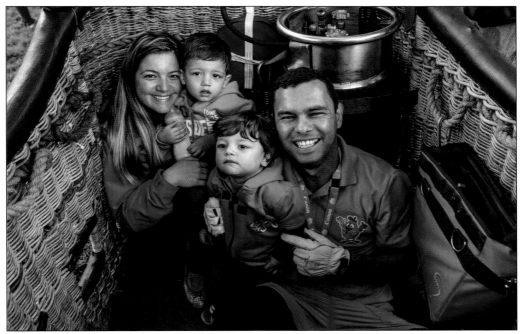

This pilot and his family have taken advantage of a "photo op" inside the balloon gondola before (or maybe after) the day's flight. (Bennie Bos.)

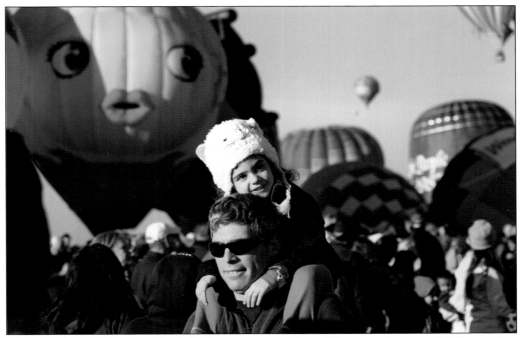

The easiest way to keep track of children is to carry them. This way, they get a bird's-eye view and parents know exactly where they are. (Ray Watt.)

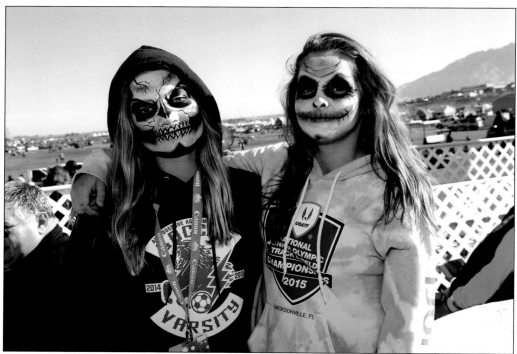

In Spanish, *fiesta* means a large feast or celebration; for many visitors at the Balloon Fiesta, dressing up is part of the fun. (Ray Watt.)

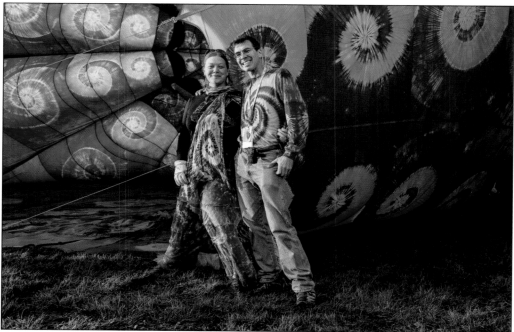

Many pilots are outfitted to match their balloons. It is easy to pick out this couple's balloon celebrating peace, love, and tie-dye. (Bennie Bos.)

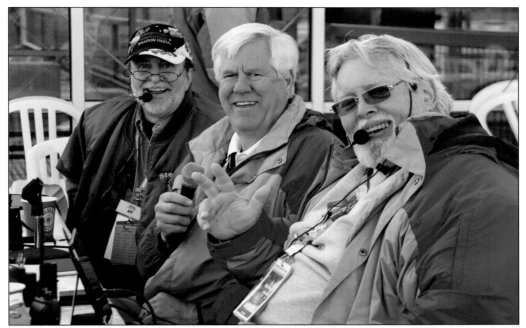

When spectators arrive on the field, they hear the announcers providing information about the flying conditions, events of the day, and interesting facts about the balloons as they launch. These are the faces behind the voices of the Balloon Fiesta—from left to right, Art Lloyd Jr., Larry Ahrens, and Glen Moyer. (Paul deBerjeois.)

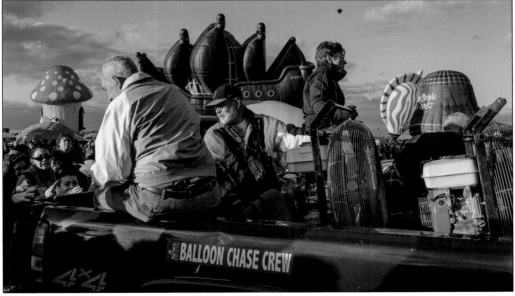

After the balloon launches, the chase crew collects the remaining equipment, loading everything into the chase vehicle. The crew drives off the field, then tries to anticipate where the balloon will land. The crew members have some help, because they will be in touch with the pilot through radio communication. Experienced pilots can often predict the general area where they expect to land based on the predicted winds aloft. (Bennie Bos.)

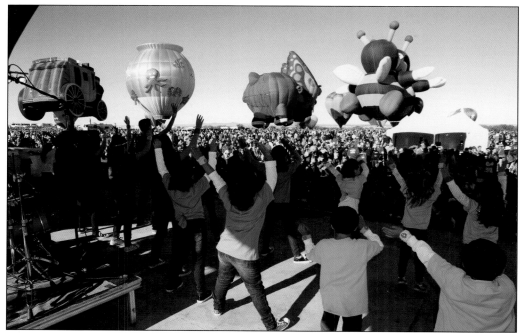

Each morning, various performers take to the stage to provide entertainment after the launch and while spectators are waiting for competitive balloons flying towards the field. After the balloons take off, there is much for spectators to see and enjoy, including performers, the Balloon Discovery Center, woodcarving, and shopping for souvenirs and delicious food. (Marlon Long.)

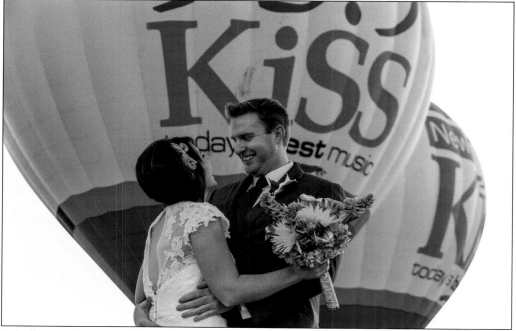

A balloon ride at the Balloon Fiesta is always memorable—and even more so if it includes a marriage proposal or is part of a wedding ceremony. (Bennie Bos.)

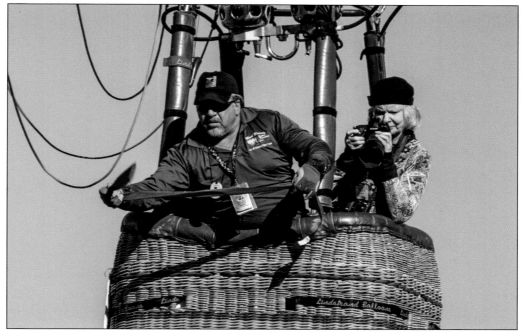

Competitive pilots love the fun of ballooning but need a challenge. This pilot appears very intense as he decides exactly when to drop his marker over the target. Chapter 2 contains much more information about the competitive events at the Balloon Fiesta. (Bennie Bos.)

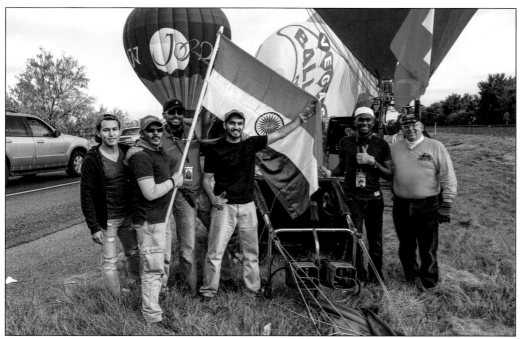

For many international balloon pilots, the opportunity to fly at the Balloon Fiesta is the chance of a lifetime. The crew for this balloon from India is celebrating a successful landing. (Bennie Bos.)

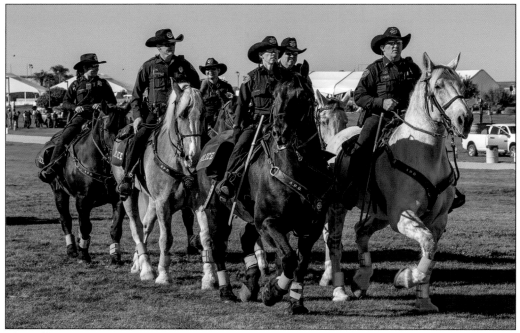

The Albuquerque Police Department's mounted patrol is the most visible of the more than 30 agencies involved in public safety at the event. (Bennie Bos.)

After the flight, it is time to relax with the chase crew and enjoy the sunny skies of Albuquerque in October. (Bennie Bos.)

Six

BEHIND THE MAGIC

Every October, for nine days, 365 mostly uninhabited acres in north Albuquerque become the state's third-biggest city. On peak days, more than 100,000 people pile into Balloon Fiesta Park. They come by car, bus, train, bike, RV, and on foot—not to mention the lucky few who arrive by balloon. While they are there, they need all of the amenities of any community: restaurants, shops, ATMs, restrooms, and more.

The park contains utilities, paving, fencing, some permanent parking, and the approximately 80 acres of grass that make up the actual launch field. The park only has three permanent buildings: the Public Safety Center, Events Center, and the 12,000-square-foot Sid Cutter Pilot Pavilion, which serves as an on-field headquarters and pilot hospitality center. Everything else has to be erected, connected, and otherwise installed in the few weeks before the Balloon Fiesta.

The care and feeding of Balloon Fiesta guests is a story in itself. About a month before the event, a dedicated staff, a cadre of volunteers (known as Navigators), and an army of vendors begin erecting tents, hauling in trailers, and placing 375 (count 'em) portable toilets. Food and merchandise vendors haul in their wares. Thousands of RVs pull into the Balloon Fiesta's three temporary RV parks. There's even a "gas station" for balloons, which pumped more than 97,000 gallons of propane (that would cook a whole lot of barbecue!) in 2015. Once the guests depart, it all has to be taken down again within three weeks. Balloon Fiesta Park resumes its role as an Albuquerque park that contains a driving range, youth sports, concerts, occasional balloon launches, and dozens of other community events ranging from fun runs to Freedom 4th.

While the Balloon Fiesta is in progress, hundreds of Navigators, contractors, vendors, performers, and the Balloon Fiesta's small staff work tirelessly behind the scenes—often for 18 or more hours per day—to insure that guests have a fun and safe experience. The next few pages offer just a small peek at what these behind-the-scenes workers do.

—Kim Vesely

When arriving at the field in the predawn darkness, the first thing most people want is a nice cup of coffee. In a small tent on the south end of Balloon Fiesta Park, staff start brewing hundreds of gallons of java before the first volunteers show up at 3:30 or 4:00 a.m. During the 2015 Balloon Fiesta, coffee-lovers consumed 110,000 cups—about 7,100 gallons—of the stuff. (Kim Vesely.)

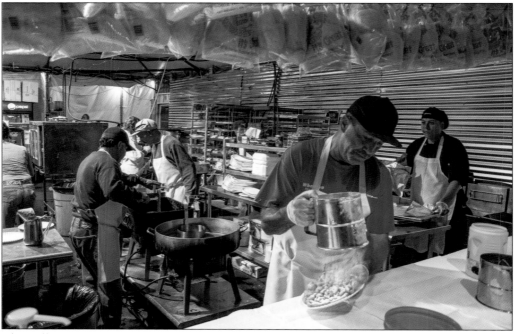

The Balloon Fiesta's Main Street offers just about anything a palate could desire, from breakfast burritos to barbecue (even at 4:30 a.m.!). Many Balloon Fiesta vendors come back year after year, and frequent Fiesta flyers line up for old favorites like these nice, hot funnel cakes. (Bennie Bos.)

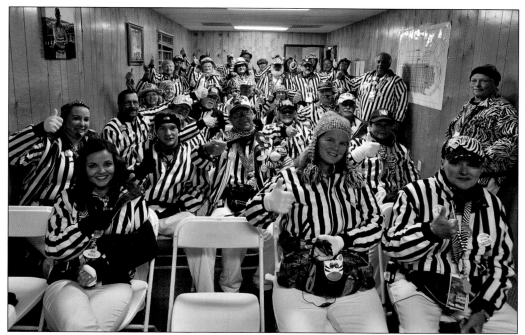

Before most pilots have even arrived at the field, teams of officials report for morning briefings at the "officials' compound" next to the Sid Cutter Pilot Pavilion. Above, the "Zebra herd" of more than 60 launch directors gets marching—or trotting—orders. Launch directors coordinate the spacing of the balloons as they ascend from the field, assist with safety, and act as Balloon Fiesta ambassadors. Nearby, the scoring officers who run the competitive events conduct a separate briefing, seen below, setting the day's competition targets and tabulating results. The balloonmeister, safety team, and weather team also hold morning briefings, and the America's Challenge Gas Balloon Race Command Center is also located in the complex. (Above, Paul deBerjeois; below, Kim Vesely.)

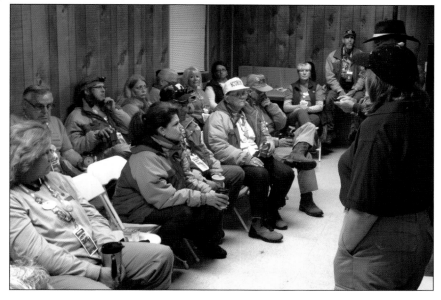

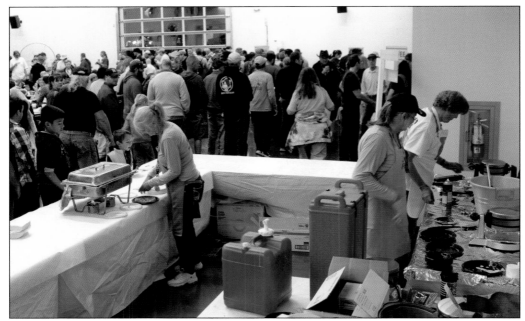

Feeding hungry "ballunatics" keeps a lot of people busy. Here, Balloon Fiesta pilot hospitality volunteers whip up fresh waffles for more than 1,000 pilots and crew. Many of the members of this loyal group of Balloon Fiesta Navigators have been baking waffles and handing out doughnuts and coffee for more than 20 years. (Kim Vesely.)

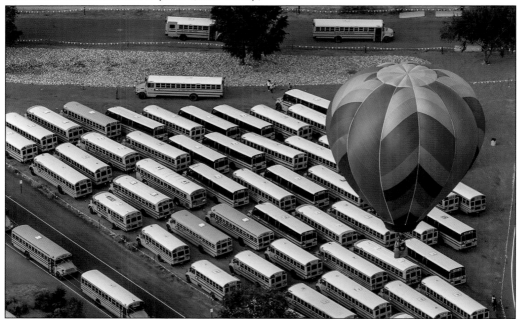

Some 200 school buses carry Balloon Fiesta guests to the event from park and ride sites around Albuquerque and in neighboring Rio Rancho. The buses belong to contractors and school districts in Albuquerque, Bernalillo, Los Lunas, and Rio Rancho. Between runs, the buses are staged in large nearby lots, giving the drivers a nice view during their downtime. (Nienke Bos.)

Volunteers from local service groups are some of the first greeters seen by Balloon Fiesta guests. For many years, they have been collecting fees and directing traffic in the Balloon Fiesta's parking lots. It is a tough job, especially in the predawn dark and cold, and they take their share of guff from impatient drivers. The steadfast service of these volunteers has greatly contributed to the safety and success of the Balloon Fiesta. (Kim Vesely.)

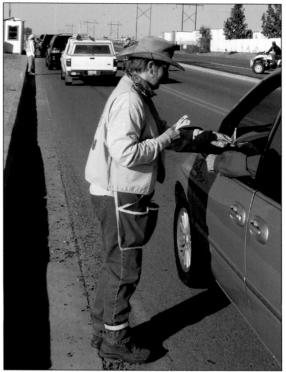

The Balloon Fiesta's 100-member security force performs a variety of tasks throughout the park, including handling gate guard duty and guest assistance. (Kim Vesely.)

Balloon Fiesta security is a huge job that requires the cooperation of local, federal, and state law enforcement agencies. The full public safety force numbers around 500, and the security precautions are every bit as sophisticated as those at any large, high-profile event, such as the Super Bowl or Rose Parade. Dispatchers from police and fire departments work in an interagency dispatch center on the field so they can coordinate their agencies' efforts. (Kim Vesely.)

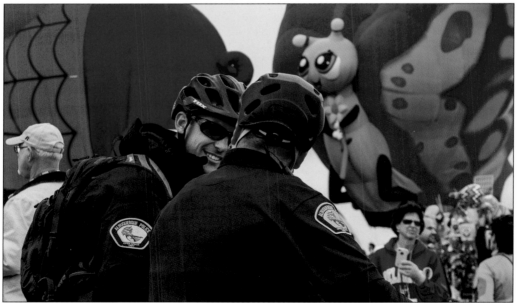

There is a lot of visible security around Balloon Fiesta Park, such as these bike officers and the popular mounted patrol. Then there is the security spectators do not see. Federal and state agencies—including the FBI, New Mexico State Police, US Marshals Service, and Homeland Security—provide comprehensive, state-of-the-art services. Their Balloon Fiesta operation gives the different agencies a chance to train and work together in real-world conditions. (Bennie Bos.)

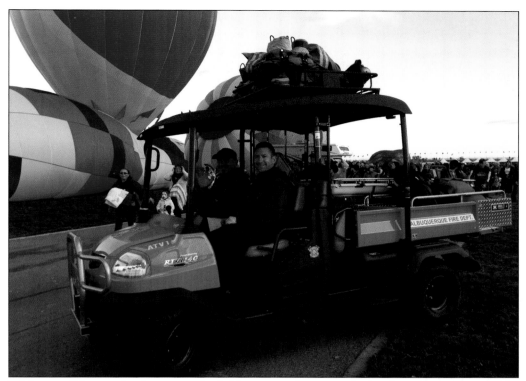

With tens of thousands of guests on the field, sooner or later, somebody is bound to twist an ankle, whack an elbow, or have a heart attack. Thanks to the first responders from the Albuquerque Fire Department and other agencies, help is just moments away. Any launch director or other official on the balloon field can summon the paramedics in case of a medical emergency. (Kim Vesely.)

The Balloon Fiesta's on-site medical center can handle everything from scrapes and bruises to serious medical emergencies, and staff can arrange for transport to a hospital if necessary. The center is located behind Main Street. (Cindy Clark.)

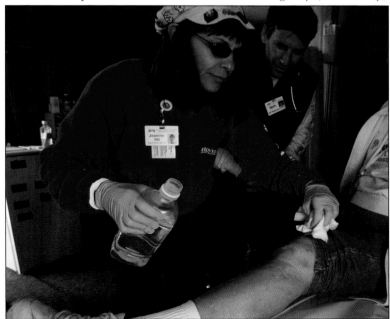

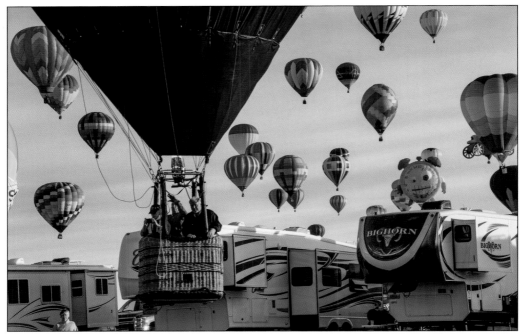

Every year, thousands of RVers camp in the three huge RV lots at Balloon Fiesta Park—and they never know who will drop in. Balloon landings are a frequent occurrence, especially in the sites south of the park. RV clubs from around the country plan rallies at Balloon Fiesta. Some guests, especially Navigators (volunteers), make Balloon Fiesta Park their October home year after year. (Bennie Bos.)

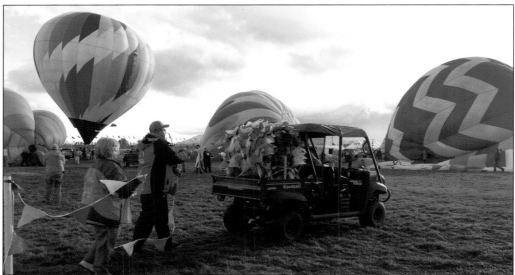

In the earliest days of the Balloon Fiesta, the event was housed at temporary sites and volunteers strung literally miles of flagging to mark off parking areas, walkways, and roads leading into the launch field. A permanently fenced site has alleviated much of this tedious work, but some flag-stringing still is necessary to rope off competition drop zones and other temporary events. Navigators help the field staff with this chore. (Kim Vesely.)

From 1997 to 2011, Sam Baxter (left) was the field manager for the Balloon Fiesta. Like so many officials, Baxter started as a balloonist and flew in the Balloon Fiesta for many years before joining the staff. Baxter was largely responsible for building the management of the huge site into a professional operation, and he did a lot of the labor himself, too. He passed away in 2011 just after the Balloon Fiesta. (Cindy Clark.)

Sam Baxter's successor Janie Jordan oversees the building of the temporary city that is Balloon Fiesta and coordinates not only with contractors and Navigators but also with City of Albuquerque Parks and Recreation and other staff involved in the year-round management and maintenance of Balloon Fiesta Park. (Kim Vesely.)

The 375 portable toilets are 375 of Balloon Fiesta Park's most important facilities. Somebody has got to keep them cleaned and stocked, and a large crew is on hand to do just that. The temporary restrooms are pumped and refreshed after every event. (Cindy Clark.)

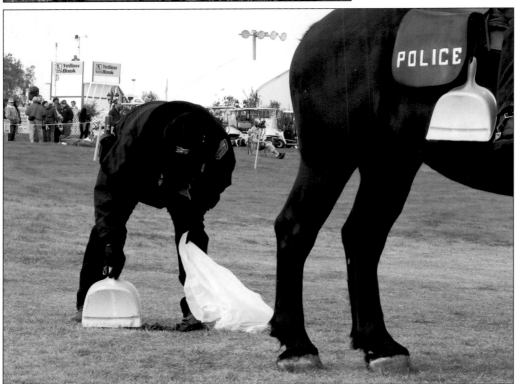

The crowd loves the mounted patrol horses from the Albuquerque Police Department and the Bernalillo County Sheriff's Posse. Both groups have been fixtures at Balloon Fiesta Park for years, and the horses are specially trained to handle the crowds and the loud noise of the balloon burners. Of course, no one— including this officer performing equine cleanup duty—is very fond of what comes out of the "business" end of a horse. (Kim Vesely.)

Maintaining enough grass to cover 56 football fields is a big job for the City of Albuquerque grounds staff that maintains Balloon Fiesta Park year-round. The Balloon Fiesta's first launch fields were dirt, which was not very inviting. The addition of grass changed the Balloon Fiesta into a true family event where parents and children can make a day of picnicking, playing, and relaxing on the green grass. (Cindy Clark.)

Approximately 1,000 Balloon Fiesta "Navigators"—better known as volunteers—assist the small event staff in just about every imaginable capacity. Navigators have their own on-field hospitality tent, where they can relax and grab a snack in those few moments when they can catch some downtime. Those interested in becoming Navigators can sign up through the Balloon Fiesta's website at www.balloonfiesta.com. (Kim Vesely.)

One of the Balloon Fiesta's most spectacular sights is the AfterGlow fireworks show held after all evening events. Each show takes hours of preparation as teams place hundreds of fountains and shells. In a carefully choreographed ballet of sight and sound, the highly trained crews then fire off everything they spent the day preparing—then they get to do it all over again for the next show. (Cindy Clark.)

A vendor from one of the 43 merchandise concessions at Balloon Fiesta Park calls it a day. (Cindy Clark.)

About Albuquerque International Balloon Fiesta, Inc., and Its Heritage Committee

By 1975, the Albuquerque International Balloon Fiesta (AIBF) had grown to 160 balloons and hundreds of thousands of spectators. Despite the shoestring budgets of the early years, the Balloon Fiesta proved that it could be viable and self-sustaining, but it had to transition from an enterprise championed by Sid Cutter and Tom Rutherford to a nonprofit organization wholly dedicated to a nine-day Balloon Fiesta each and every October.

Harry Kinney, who served as Albuquerque's mayor from 1974 to 1977 and again from 1981 to 1985, was the spark plug that lit the fire under the nonprofit organization known as Albuquerque International Balloon Fiesta, Inc. With Mayor Kinney's blessings and some strategic arm-twisting, the Balloon Fiesta has been flying high for 45 years. The organization has a 24-member board of directors and an executive director. The AIBF offices are located on Alameda Boulevard, just a quarter mile south of the launch field at Balloon Fiesta Park and the world-renowned Anderson-Abruzzo Albuquerque International Balloon Museum.

Among the Balloon Fiesta's various committees is the Heritage Committee, created by Dr. Tom McConnell in the summer of 1998 as a "permanent AIBF committee to monitor, save, promulgate and report on the history, property of historical importance and traditions of the annual event and the corporation." The committee produces the official program each year and recognizes individuals who have made significant contributions to the Balloon Fiesta through the organizing of historic mementos, improving safety programs, ensuring great venues for visitors, ensuring photographic and written records of each event, and educating the public about hot air and gas ballooning.

Regarding the latter, four members of the Heritage Committee produced the award-winning book *The World Comes to Albuquerque—The Dream Takes Flight* in 2011. New Mexico Book Awards honored the work as "2011 Best of Show" and winner in the art and photography categories.

The Heritage Committee is now chaired by John Davis. Its members include Wally Book, Dick Brown, Jacqueline Hockey, Charlotte Kinney, Rod May, Tom McConnell, Dick Rice, Marilee Schmit Nason, Harry Season, John Sena, Al Tetreault, Kim Vesely, and Ty Young—all of whom are volunteers.

Speaking of volunteers, an old African proverb states that "it takes a village to raise a child." For the massive undertaking that is the Albuquerque International Balloon Fiesta, it takes a large city to raise so many balloons. Every year, an army of volunteers—thousands of volunteers—comes together to ensure a safe and successful event.

Discover Thousands of Local History Books Featuring Millions of Vintage Images

Arcadia Publishing, the leading local history publisher in the United States, is committed to making history accessible and meaningful through publishing books that celebrate and preserve the heritage of America's people and places.

Find more books like this at
www.arcadiapublishing.com

Search for your hometown history, your old stomping grounds, and even your favorite sports team.

Consistent with our mission to preserve history on a local level, this book was printed in South Carolina on American-made paper and manufactured entirely in the United States. Products carrying the accredited Forest Stewardship Council (FSC) label are printed on 100 percent FSC-certified paper.

MADE IN THE USA